IMAGES
*of America*

# LAKE
# PONTCHARTRAIN

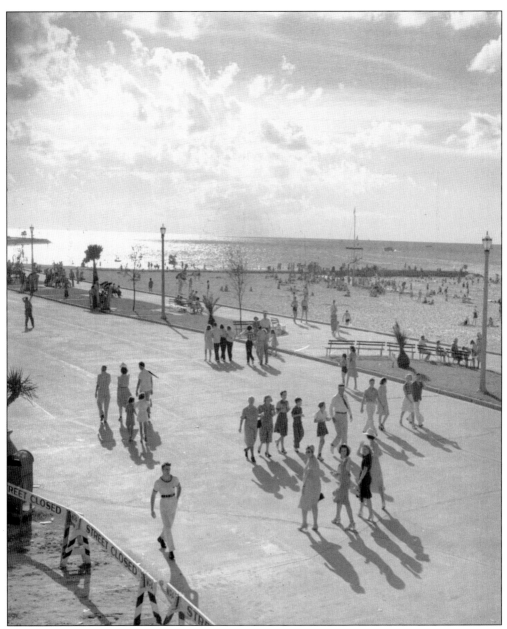

**ON THE COVER:** Fond in the memories of many New Orleanians, Pontchartrain Beach amusement park attracted swimmers and pleasure seekers of all ages who enjoyed the pool, the man-made beach, the rides, concessions, penny arcade, Laff in the Dark, and Bali Hai restaurant. Entertainment included stage shows, the annual Miss New Orleans Pageant, and a 1956 Elvis Presley performance. Originally opened across Bayou St. John from Spanish Fort in 1928, the amusement park moved to its final location on Elysian Fields Avenue in 1940, when this photograph was taken. (Courtesy New Orleans Public Library.)

IMAGES
*of America*
# LAKE
# PONTCHARTRAIN

Catherine Campanella

ARCADIA
PUBLISHING

Published by Arcadia Publishing
Charleston SC, Chicago IL, Portsmouth NH, San Francisco CA

Printed in the United States of America

Library of Congress Catalog Card Number: 2006934709

For all general information contact Arcadia Publishing at:
Telephone 843-853-2070
Fax 843-853-0044
E-mail sales@arcadiapublishing.com
For customer service and orders:
Toll-Free 1-888-313-2665

Visit us on the Internet at www.arcadiapublishing.com

*To my family, who taught me to treasure the lake.*
*A portion of the proceeds from this book is dedicated to the*
*Lake Pontchartrain Basin Foundation's efforts to rebuild the*
*historic New Canal Lighthouse.*

# CONTENTS

# FOREWORD

Lake Pontchartrain is as much a part of New Orleans as the Mississippi River, jazz, and streetcars. Actually, Pontchartrain is not really a lake. Technically a lake is completely surrounded by land. Because of the Rigolets and Chef Menteur tidal passes to the Gulf of Mexico, Pontchartrain is more accurately an inland bay or estuary. An estuary is an area where fresh water from rivers mix with the salty water of the sea. Estuaries are some of the most productive habitats on the good Earth, and Pontchartrain is one of the largest along the Gulf Coast. But Pontchartrain is much more than an environmental treasure; it's part of us. It means many things to many people.

Pontchartrain has influenced the history and culture of Southeast Louisiana since the first American Indians began roaming the region. It continues to do so to this day. In this book, Cathy Campanella has captured more than just history and culture. She has captured the memories—the memories that make our region and each of us what we are today.

Photographs and captions help us remember tales like those my grandfather told me about riding "Smokey Mary" to the lakefront, over the Rhine, steamers to the north shore, and storms. Most make me smile recalling days as a kid exploring Spanish Fort and Fort Pike, my dad's patience teaching me to swim in the lake, eating watermelons and slurping snowballs on the seawall during warm summer nights, the anticipation of a trip to Pontchartrain Beach, the smells and sounds of the wonderful restaurants of West End, crabbing and fishing, and the camps. Cathy's family had one of the last camps to grace the south shore. Other, more sobering memories include the dark, howling night of Hurricane Betsy and, almost 40 years to the day later, Katrina.

While many of these memories may never be again, they should not be forgotten. They can help us remember and mimic the good and learn from and build upon the not so good. I hope you enjoy Cathy's work. It well describes what makes Pontchartrain, Southeast Louisiana, and its residents unique.

—Carlton Dufrechou
7 December 2006
New Orleans

# ACKNOWLEDGMENTS

Had Amelia Boesch not married William Ahten in 1903, this book might not have been written. Millie and Willy's camp, the Amelia A along Hayne Boulevard, was the first to be owned in five generations of my family. Although I have no recollection of Aunt Millie, some of my fondest memories are of times spent at camps and of the stories about the lake told by her sister, my great-grandmother Augusta "Gussie" Boesch, and my great-grandfather Edward Knower—a storyteller of major proportions. Through them and offshoots of family branches including members of the Maylie, Mondello, and Pohlmann families, I learned to love and respect Lake Pontchartrain—how could one not do that when embraced by family and the lake in a camp built just above its waters?

My lifelong friends Eddie and Shirley Krass and their children, Blake, Julie, Amy, and Gail shared countless days, invaluable work, and their outrageous sense of fun with us at the camp. I thank them and all friends who helped and joined us in making glorious memories.

Dan Rein, former "Mayor of Little Woods," and his wife, Annette, owners of the Hayne Boulevard camp Six Little Fishes, shared wonderful stories about life on the lake. I am indebted to them for that as well as for being good neighbors on the lake who never failed to come to our rescue.

Finally, and most importantly, I thank Meredith and Vincent Campanella, my parents, for giving my children, my husband, and me the opportunity to live on Lake Pontchartrain in a camp built in 1925. It was first named St. John's Cottage, then Lakecrest Cottage, and finally renamed for my family—Camp-a-Nella. It was a treasure.

Information found here would not have been available without the work of writers, photographers, historians, archivists, and local nostalgia buffs who researched the history of Lake Pontchartrain long before I began this endeavor. Special thanks to Irene Wainwright, archivist of the New Orleans Public Library, for assistance in acquiring many of the photographs found here. Other photographic sources include the Library of Congress and the Louisiana Digital Collection, among others. Much information about jazz on the lake was gleaned from the Red Hot Jazz Archive. Family photographs and invaluable information were generously shared by Connie Adorno Barcza, Dawn Bowers Benfield, Beth Fury, Anne Harmison, Henry Harmison, Julie Krass Kroper, Jason Perlow, Amy Cyrex Sins, and Poppy Z. Brite. Uncredited photographs are in the author's collection.

# INTRODUCTION

Lake Pontchartrain has been many things to many people—an ancient trade route, a commercial asset, a source of food and great pleasure. It is a beautiful, often tranquil, body of water that has raged with wind-driven waves countless times before recorded history and many times thereafter. Each time the lake overflowed its boundaries, determined members of the surrounding communities saved whatever they could and built their lives anew, because there is a love for this place that is stronger than even the most powerful storm.

Hurricane Katrina will not be remembered by most residents around Lake Pontchartrain as "The Storm." It was not the storm that resulted in the massive devastation in this area, but rather it was "The Flood." (New Orleans *Times-Picayune* columnist Chris Rose aptly coined it "The Thing.") After the hurricane winds passed over, most residents took stock of the relatively limited damage, said a silent prayer of thanks, and gleefully commented to each other, "We dodged the bullet." Then federally engineered, man-made levees and canal walls broke, allowing storm-driven Gulf of Mexico waters that had been pushed into the lake and canals to inundate the area.

It has been said that New Orleans has more canals than Venice. The first major governmental project near Lake Pontchartrain was the construction of a canal in 1795 to connect the city of New Orleans (near the Mississippi River) to Bayou St. John, which served as a trade route to the lake. From the lake, vessels would pass through the Rigolets and eventually into the Gulf of Mexico. This route, shown to French explorer Pierre LeMoyne, Sieur d'Iberville, in 1699 by members of the Biloxi and Bayogoula tribes, was easily navigable in both directions, as opposed to the longer path to the gulf via the river and the practically impossible upriver trip against the tide in the days before the invention of the steamboat. This first man-made channel, commissioned by and named for the Spanish governor Francisco Luis Hector, Baron de Carondelet, also served to aid drainage of the low-lying swamps between the city and the bayou.

During the early 1800s, a proposed canal connecting the Carondelet Canal basin to the river was never built but lent its name to the street on which it was planned—Canal Street. The second major canal, this one constructed under American rule, connected the city (not far from the Carondelet Canal basin) to the lake at West End. The New Basin Canal was dug during the 1830s, primarily by newly landed Irish laborers. The workers risked mosquito-transmitted diseases while toiling through the swampy quagmire, and many died; they were hired because their lives were considered by the builders to be less valuable than those of their slaves. Upon completion, the New Basin Canal and the shell road along side it allowed another route for trade via the lake and gave city dwellers a new path to the lakefront (the Pontchartrain Railroad had already begun its run along Elysian Fields Avenue to Milneburg in 1832).

Through the years, as the city of New Orleans expanded toward the lake, more canals were dug. The London Avenue Canal was commissioned by Alexander Milne during the mid-1800s to be used primarily for navigation to and from the lake but also as a means to drain outlying swampland. The notorious Seventeenth Street Canal (formerly called the Upperline Canal) is said to have been dug not primarily for drainage but to build a bed for the Jefferson and Lake Pontchartrain Railroad tracks from the City of Carrollton to the lake.

The U.S. Army Corps of Engineers completed the Industrial Canal in 1921. It was the first to actually connect the river to the lake and subsequently to the Gulf of Mexico. By 1965, the corps had completed the bisecting Mississippi River Gulf Outlet (MRGO). This problematic channel provided yet another shortcut between the river and gulf—this one between the Gulf of Mexico and the Industrial Canal—but it was later realized that it also allowed saltwater intrusion from the gulf into St. Bernard Parish and the Lake Pontchartrain Basin, resulting in the loss of protective freshwater marshes and wetlands. Due to erosion and lack of maintenance, by 1989 the MRGO was three times wider than its original 650-foot design. In recent years, it handled an average of one vessel per day. In August 2005, the MRGO allowed Hurricane Katrina's gulf surge a direct and amplified path to communities along its 66-mile route, to residences and businesses along the Industrial Canal, into Lake Pontchartrain, and subsequently to surrounding areas.

All those canals and channels were created to get to this lake, which is surrounded by six parishes—Orleans, St. Tammany, Tangipahoa, St. John the Baptist, St. Charles, and Jefferson—Lake Pontchartrain is said to be the second-largest salt-water lake in the United States (the Great Salt Lake is the largest); this is disputable because Lake Pontchartrain is also considered a brackish estuary. It encompasses 630 square miles, running approximately 40 miles east to west at its widest point and 24 miles north to south between Metairie and Mandeville. Its average depth is 12 to 14 feet but was considerably deeper in centuries past. It has been estimated that Lake Pontchartrain is 2,500 to 4,000 years old, and it is the home of over 125 species of fish.

Beginning on the south central shore and running clockwise around the lake can be found the unincorporated community of Metairie which includes the small Bucktown community and the southern terminus of the world's longest over-water span (the Lake Pontchartrain Causeway); the city of Kenner; the Bonnet Carré Spillway, which diverts water from the Mississippi River into the lake during high river tides; Pass Manchac, which connects to Lake Maurepas; the city of Madisonville at the Tchefuncte River; Mandeville (the northern terminus of the Causeway); Fontainebleau State Park; and Orleans Parish, which includes Fort Pike at the Rigolets, Pointe Aux Herbes at the southern end of the Maestri/Five Mile Bridge, the Chef Menteur Pass leading to Lake Borgne, Little Woods, Lincoln Beach, the New Orleans Lakefront Airport, the Inner Harbor Navigation Canal/Industrial Canal, the University of New Orleans, Bayou St. John, and West End.

We begin this pictorial history where Bayou St. John met the lake, because it was here that Iberville decided to settle. The rest is a glimpse of the modern history of Lake Pontchartrain. Mark Twain, Kate Chopin, and Harriet Beecher Stowe wrote about it. Simple fishing camps and elaborate resorts were built along its shores. A Confederate submarine and World War II Higgins boats were built and tested near and on its waters. Elvis was there, as were many of the early jazz greats. There was a fort with an amusement park. Now there's a technology park with a lighthouse. There was a rousing lakefront town that found itself a half-mile inland a century later. The first lighthouse built outside the 13 original colonies was built on Lake Pontchartrain. The second railroad in the United States connected the lake to the city of New Orleans. Three times Lake Pontchartrain was able to claim having the world's longest bridge. Local legend tells of a brewer who offered $10,000 to the winner of the Jax Golden Gill Fish Hunt. It is a colorful history.

Much of what you'll see here is gone now due to progress, Mother Nature's wrath, human error, or some combination thereof. The only real constant is and has been the struggle to survive and thrive near this bountiful lake, which provides so much beauty and pleasure.

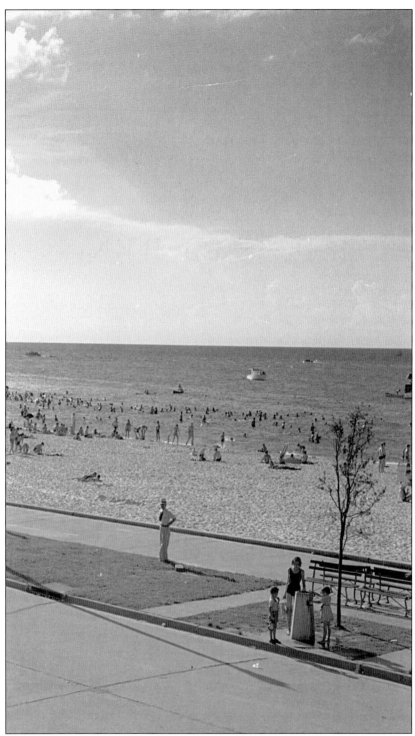

The man-made Pontchartrain Beach is featured in this 1940 photograph taken shortly after it was completed. The beach and the adjoining property is now the home of New Orleans Research and Technology Park. (Courtesy New Orleans Public Library.)

# One

# THE BEGINNING

Historic markers near Lake Pontchartrain offer terse commentaries but pay homage to Native Americans who first inhabited the land surrounding the lake. They include: "Lake Pontchartrain—. . . Indians called it Okwa-ta, wide water," "New Orleans—First sited as Indian portage to Lake Pontchartrain and Gulf . . . ," "The Old Portage—Short trail from Lake Pontchartrain to river shown by Indians to Iberville and Bienville, 1699," "Mandeville—. . . Near this site Bienville met, in 1699, Acolapissas who reported that, two days before, their village had been attacked by two Englishmen and 200 Chicasaws," and "Tangipahoa— . . . Town named for Indian tribe."

The Tangipahoa people are best remembered now for the parish as well as the river named for them. Tangipahoa comes from an Acolapissa word meaning "those who gather corn." The Tchefuncte tribe was likewise recognized; the river that enters Lake Pontchartrain at Madisonville bears their name.

Prior to the arrival of Europeans, a Choctaw village of the Houmas tribe (who viewed the crawfish as a sign of bravery) settled along Bayou St. John where it met Lake Pontchartrain. They named the lake *Okwa-ta*. Bayou St. John was called Bayouk Choupic for the "mud fish" (also known as bowfin or cpyress trout) that lined its edges. The word bayou comes from the Choctaw word for "minor streams."

The bayou was used for transportation and trade. Native Americans discovered that by using it and a natural, elevated ground path (now Bayou Road), they could travel from the Mississippi River at present-day New Orleans to the lake, through the Rigolets Pass, and into the Gulf of Mexico.

When the French arrived, they sought a shorter route from their small settlement to the gulf—shorter than the plodding, meandering upriver passage from the river delta. It was the Biloxi tribe who showed them the way. One could say that had the native people not so generously shared their knowledge, the history of Lake Pontchartrain and the surrounding communities might be quite different.

The French built Fort St. Jean at the mouth of the bayou to protect their settlement from attack via the lake. Spanish governor Carondelet constructed a canal to connect the city to the bayou. It would be the fist of many plans to engineer a direct route to the lake. By 1818, a lighthouse guided sailors there, and two more forts, Pike and Macomb, were constructed on the eastern shore.

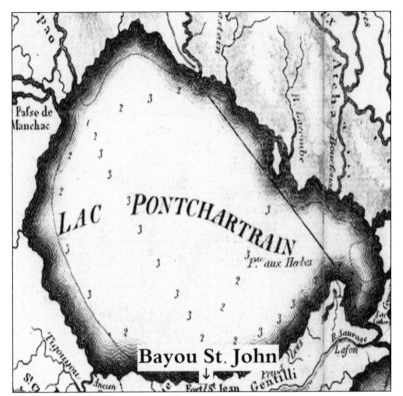

This map includes an overall view of Lake Pontchartrain and indicates the approximate location of Bayou St. John at Lake Pontchartrain.

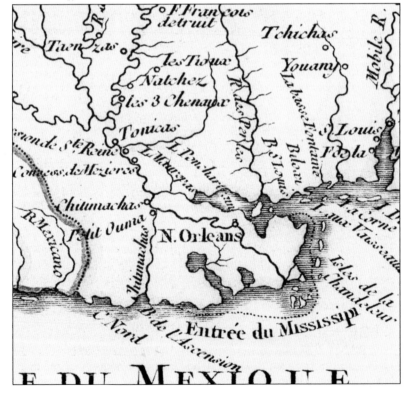

This portion of a 1749 French colonial map entitled "Cours du Mississipi et La Louisiane" by Robert de Vaugondy shows Native American tribe locations as well as Lake Pontchartrain and a primitive view of the east/west navigational shortcut between the Gulf of Mexico and the lake. (Courtesy Louisiana Digital Library.)

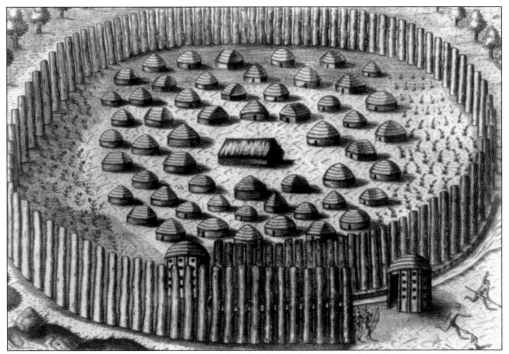

When Iberville came upon the spot he would later name New Orleans, he saw a Bayougoula village comprised of straw-roofed huts surrounded by a circular protective wall of cane and saplings. (Courtesy Library of Congress.)

The Houmas tribe called Bayou St. John "Bayouk Choupic" for the mud fish, which lined its edges. (Courtesy Library of Congress.)

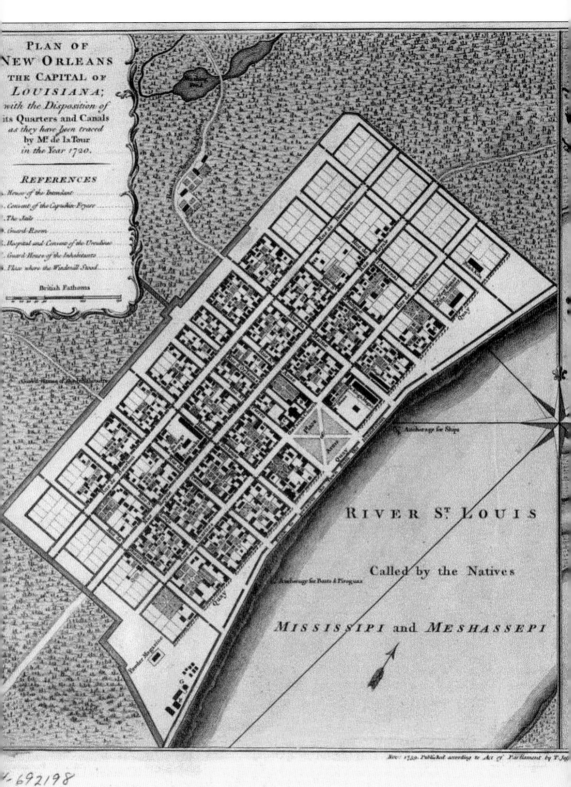

PLAN OF
NEW ORLEANS
THE CAPITAL OF
*LOUISIANA;*
*with the Disposition of*
its Quarters and Canals
*as they have been traced*
by M.ʳ de la Tour
*in the Year 1720.*

REFERENCES

. *House of the Intendant*
. *Convent of the Capuchin Fryars*
. *The Jail*
. *Guard-Room*
. *Hospital and Convent of the Ursulines*
. *Guard-House of the Inhabitants*
. *Place where the Windmill Stood*

British Fathoms

Anchorage for Ships

RIVER St LOUIS

Called by the Natives

MISSISSIPI and MESHASSEPI

Nov.ʳ 1759. Published according to Act of Parliament by T. Jef.

1-692198

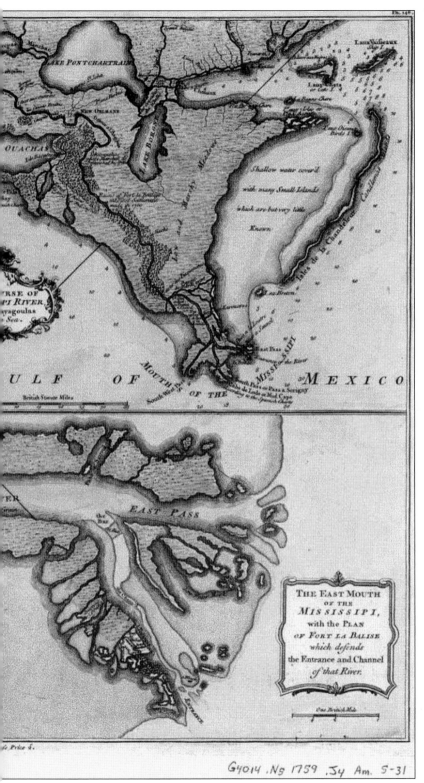

This 1759 map illustrates the short natural trail (left) through surrounding swamp that connects the Mississippi River (and New Orleans) to Bayou St. John and the connecting waterways (top right) leading to the Gulf of Mexico. (Courtesy Library of Congress.)

Iberville's Native American guide showed him a nearby ancient road through the forest that was used as a portage, allowing inhabitants to carry their canoes approximately one mile from the Mississippi River to Bayou St. John, which led directly to Lake Pontchartrain. From the lake, one could easily navigate to the Gulf of Mexico near Biloxi. (Courtesy Library of Congress.)

In this photograph, Bayou St. John meets the lake, probably in 1948. Note the relatively straight walls of the channel near the lake compared to the winding shore of the old bayou. Where the two meet (approximately at what is now Robert E. Lee Boulevard) was the original lakeshore before land was reclaimed during the 1920s and 1930s. It was to this point that Pierre LeMoyne Sieur d'Iberville was led by Native Americans. (Courtesy New Orleans Public Library.)

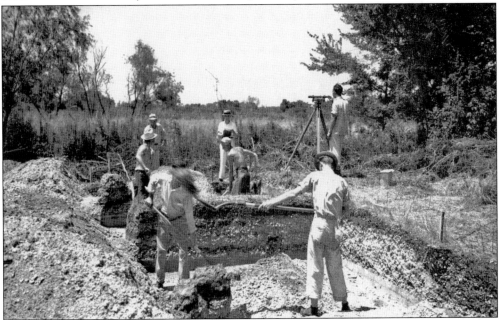

The photograph shows Works Progress Administration (WPA) workers during the 1940s finding evidence of Tchefuncte period Native Americans near the lake two miles from the Lakefront Airport, which was then called Shushan Airport. (Courtesy New Orleans Public Library.)

| STATE | COUNTY | TOWN OR VICINITY |
|---|---|---|
| LOUISIANA | ORLEANS | NEW ORLEANS, LA 5s<br>BAYOU ST. JOHN AT 27p<br>LAKE PONTCHARTRAIN. 14d |

| INDEX NUMBER | MONUMENT | HMI |
|---|---|---|
| LA, 36-NEWORN, 1- | | SPANISH FORT (FORT ST. JOHN) |

| REPRESENTED IN NEGATIVE FILE | H.A.B.S. SURVEY NO.<br>18-25 ✓ | HISTORY ~ BUILT 1807-1809 BY U.S. WAR DEPARTMENT ON SITE OF EARLIER SPANISH FORTIFICATION. |
|---|---|---|
| PUBLISHED PHOTOGRAPHS | | GARRISONED DURING WAR OF 1812. SOLD ABOUT 1823 TO HARVEY ELKIN WHO ERECTED A HOTEL THERE. |
| PUBLISHED DRAWINGS | | LATER BECAME AN AMUSEMENT PARK. NOW ABANDONED. OWNED BY NEW ORLEANS PUBLIC SERVICE INC. |
| * - ONE PRINT MISSING<br>F.N. - 12,<br>1d = PLOT PLAN<br>•ro    6—8369 | | DESCRIPTION~ SMALL BRICK FORTIFICATION NOW IN RUINS.<br>REFERENCES ~ HISTORICAL DATA OF SPANISH FORT, J. H. DEGRANGE –<br>HISTORIC AMERICAN BUILDINGS SURVEY<br>(OVER) N |

The French established Fort St. Jean in 1701 on Bayou St. John at the Lake Pontchartrain shore. This page from a 1934 Historic American Buildings Survey gives a brief account of its history but includes no mention of the original French fort. (Courtesy Library of Congress.)

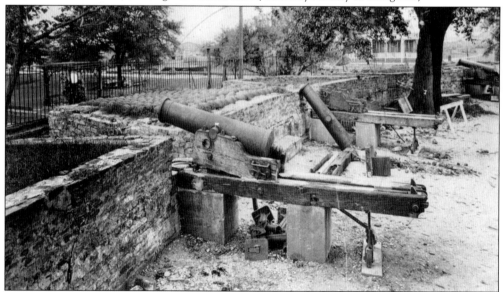

Cannons at Spanish Fort are pictured in this 1910 photograph. By this time, they were surrounded by the resort and amusement park. The property was sold to Harvey Elkins by an act of Congress in 1823 after the port had been decommissioned. Later owners included John Slidell, New Orleans City and Lake Railroad, Moses Schwartz, New Orleans Public Service, and the Orleans Parish Levee Board. Near this spot, local legend tells of Sancho Pablo, a Spaniard stationed there, who fell in love with an Native American maiden and was killed by her father when he discovered them under the trees where he is buried. (Courtesy Library of Congress.)

18

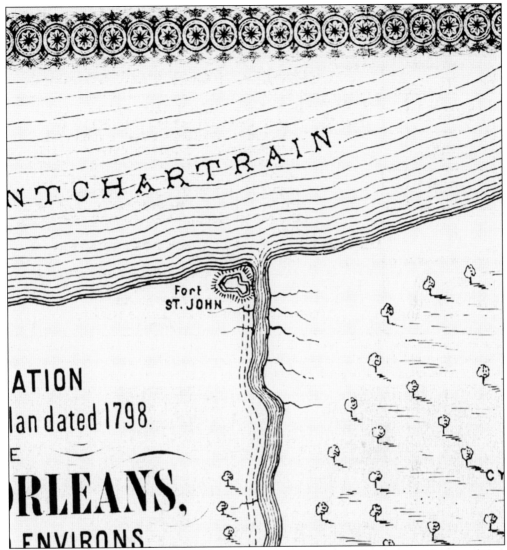

In 1795, Spanish governor Carondelet began construction of a canal to connect the city of New Orleans to Bayou St. John for navigation to the lake. The canal also served to drain the swamps between the lake and the city. This 1798 plan includes a view of Bayou St. John at the lake. (Courtesy Louisiana Digital Library.)

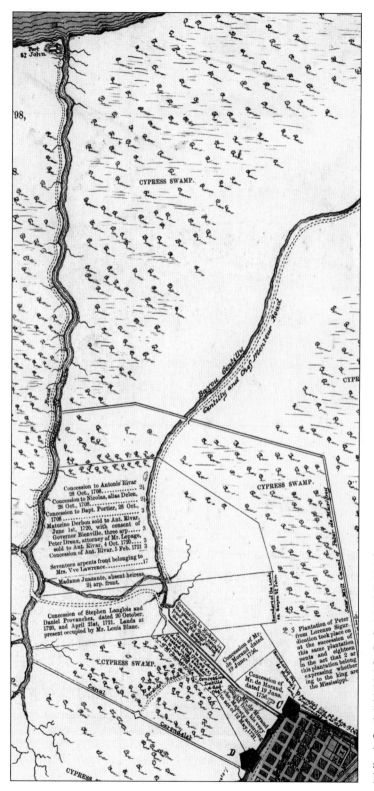

This 1798 map includes the route of the Carondelet Canal between the city and Bayou St. John. Land concessions at the right of the bayou include owners Antonio Rivar, Maturino Derbou, Peter Dreaux, and Stephen Langlois. Note that the original settlement of New Orleans was surrounded by swampland. (Courtesy Library of Congress.)

This 1828 plan includes the Carondelet Canal (D) and another canal (C) which would lead to Bayou Gentilly. Note that the Carondelet Canal basin abutted the city rampart (later to be named Rampart Street). The canal lead to St. Peter Street. (Courtesy Louisiana Digital Library.)

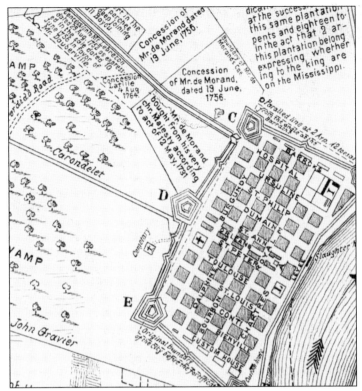

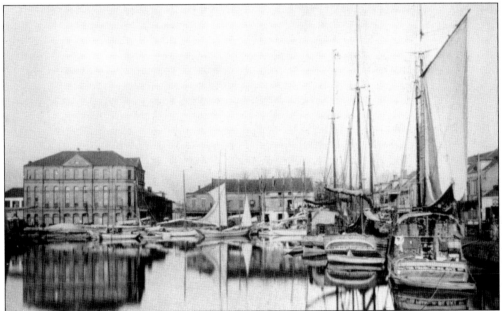

The turning basin/terminus of the Carondelet Canal at St. Peter Street and Basin Street was near the present site of the Municipal Auditorium. Basin Street owes its name to the turning basin. In this undated photograph, oyster luggers are docked at the basin. Oyster dealers remained on Rampart Street long after the canal and basin were covered during the late 1920s. (Courtesy New Orleans Public Library.)

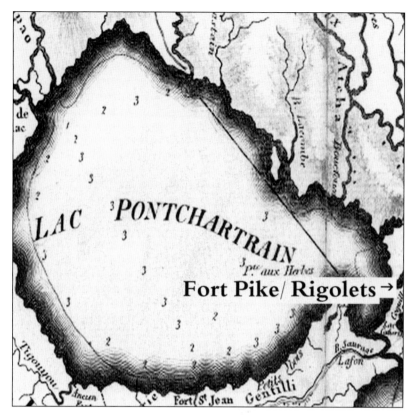

In 1818, two additional forts were constructed. Fort Pike guarded the Rigolets, and Fort Macomb protected Chef Menteur Pass. This map indicates the approximate location of Fort Pike and the Rigolets. Fort Macomb/Chef Pass is slightly farther south along the eastern edge of the lake.

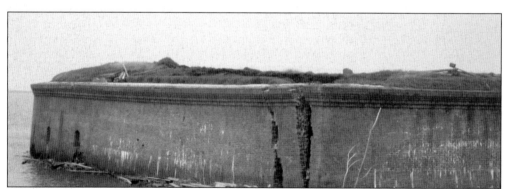

Fort Pike was built to guard against British attack by way of the Rigolets. In 1861, the Louisiana Continental Guard took command of it, but Union forces reclaimed the fort in 1862. Fort Pike had been in poor condition for many years then badly damaged by Hurricane Katrina, as can be seen by the cracks in the center of this photograph, but much of it still survives. (Courtesy Wikipedia.)

This photograph shows a 1930s survey team on site at Fort Pike. Note the West Rigolets Lighthouse in the background. (Courtesy Louisiana Digital Library.)

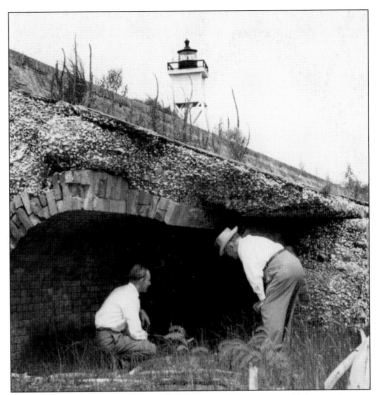

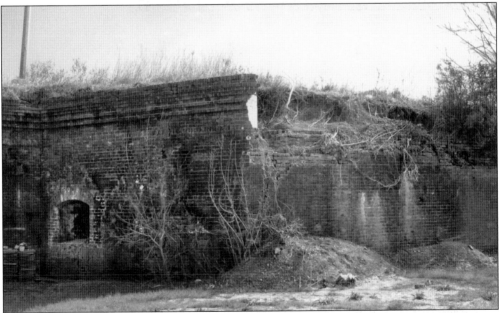

On a vintage postcard, Fort Macomb is described: "Fort McComb guards the entrance from the Gulf of Mexico, into the chain of salt water lakes that are located back of the city. The walls of this fort are 40 feet thick, and the roof is many feet deep with turf. There is a Moat thirty feet wide, and twenty feet deep surrounding this fort, with drawbridge to give entrance." (Courtesy Wikipedia.)

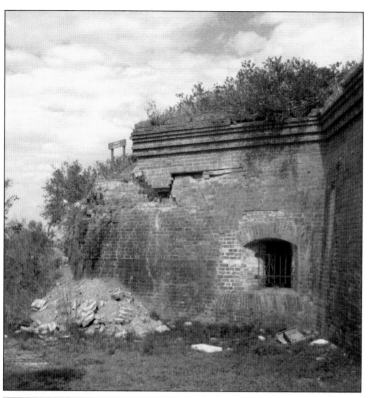

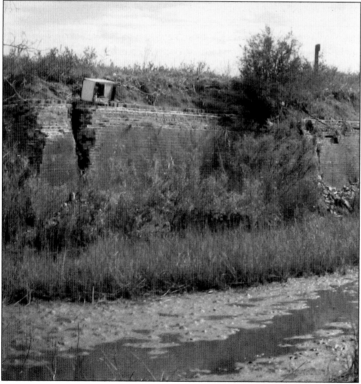

The remains of Fort Macomb are viewed in these recent photographs. Note the cracks and damage caused by Hurricane Katrina. (Courtesy Wikipedia.)

# Two

# MILNEBURG

During the early 1800s, Milneburg (pronounced "Milenburg" by old time New Orleanians) sprang up on the shore east of Bayou St. John. It was named for its founder, Scottish philanthropist Alexander Milne, who had made a fortune in the hardware and brick-making businesses. At the time of his death in 1838, Milne owned 22 miles of land along the lakeshore from the Rigolets to Jefferson Parish.

Milneburg developed into a thriving port (sometimes referred to as "Lakeport") handling goods shipped to and from Mobile and survived the 1831 hurricane that brought lake waters as far as Dauphine Street. A lighthouse was constructed there in 1832. Within the same year, the Pontchartrain Railroad began its five-mile, 100-year run from the river along Elysian Fields Avenue. The famous "Smoky Mary" allowed easy access for city dwellers to this area of the lakefront, where they could spend time at the Washington Hotel or the simple fishing camps, relax in the park or a saloon to hear early jazz greats, enjoy a meal at one of many restaurants, or simply swim. Most of the structures at Milneburg were built over the lake on pilings, many of them connected to one another by wooden walkways.

The steamers *New Camellia*, *Abita*, and *Heroine* ran between Milneburg and the resorts and docks on the north shore. In 1872, enterprising German immigrant Fritz Jahncke rented a single steam dredge on the south shore, navigated it to Madisonville, dug up white Tchefuncte River sand, and shipped the sand back to New Orleans to be used for making bricks and concrete. Like Alexander Milne, Jahncke began his fortune in brick making. Jahncke expanded the business to include supporting industries that impacted the north and south shores—boat building, repair, and shipping. During World War I, the Jahncke Shipyard in Madisonville was contracted to build ships for the U.S. Navy.

Milneburg's importance as a port declined during the Civil War when trade with Mobile was no longer possible. By 1870, the port was even less viable due to the opening of the New Orleans, Mobile, and Chattanooga Railroad, but Milneburg continued to thrive as a lakefront resort, recreation area, and birthplace of jazz until the 1920s and 1930s, when land reclamation projects left the community about a half-mile from the shore. The Port Pontchartrain Light (also known as the Milneburg Lighthouse), which was built on piers in the lake, was then surrounded by concrete in Kiddieland at the Pontchartrain Beach amusement park.

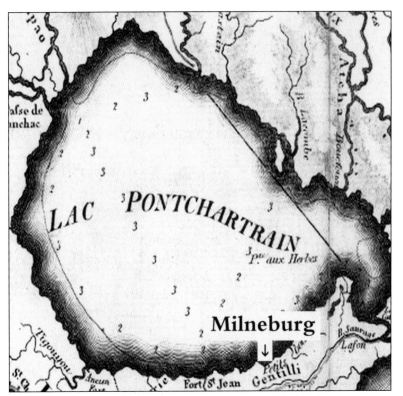

This map shows the former location of Milneburg. The town was on the lake until approximately one half-mile of land was filled along the shore.

This 1893 map includes views of the locations of Spanish Fort/ Bayou St. John, and Milneburg along the New Orleans lakeshore, as well as the route of the Pontchartrain Railroad. Metairie Ridge Road is now most often called the Gentilly Ridge. (Courtesy Louisiana Digital Library.)

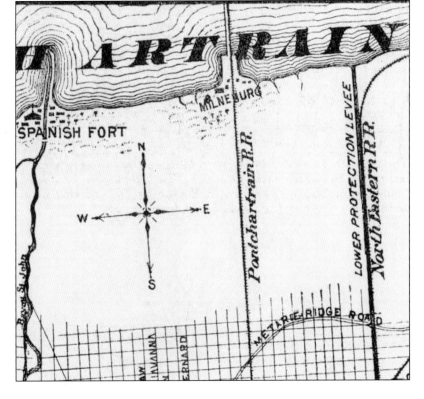

This map detail includes the streets of Milneburg, which was on the lakeshore before land reclamation projects during the 1920s and 1930s. According to one account, in 1839, the town of Milneburg consisted of a few houses, the Washington and Arch Hotels, a grocery, two barrooms, and a bakery. (Courtesy Louisiana Digital Library.)

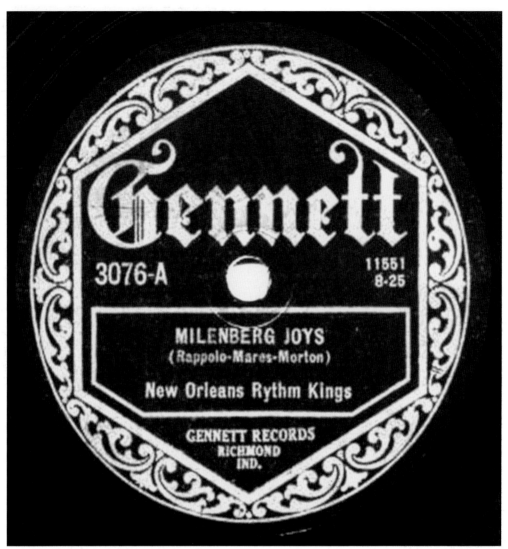

In 1923, the New Orleans Rhythm Kings recorded "Milenberg Joys." The band included Paul Mares, George Brunies, Jelly Roll Morton, and Leon Rappolo. "Milenberg" was the common New Orleans pronunciation for Milneburg. Jelly Roll Morton, although given credit for the composition, claimed only to have written the introduction. (Courtesy doctorjazz.co.uk.)

Several women kept the lights on Lake Pontchartrain. Margaret Norvell served at the Head of Passes Light (1891–1896) and the Port Pontchartrain Light (1896–1932). Margaret rescued numerous shipwreck victims and assisted many others in distress. When a 1903 storm swept through Milneburg, she cared for over 200 people who had been left homeless. The lighthouse is shown here during the 1940s. (Courtesy New Orleans Public Library.)

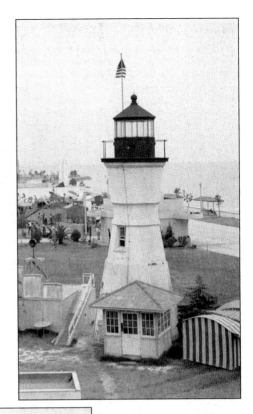

N. O. Times - June 25, 1870 (Sat.)
Vol. VIII - No. 4058
P. 6 - Col. 2

(35)D

#### The Voudous' Day

St. John's Day is the great day for the voudous, and is greatly celebrated, in their usual style, at the Lake, between Bayou St. John and Lakeport. A number of wooden shanties and stands have been erected there, and already last night a large exodus of men and women took place from the Second and Third Districts for the Lake.

Voudou dances commenced last night at twelve o'clock, and will be kept up until tonight at twelve o'clock. Marie Levou, Eliza Nicou, Euphrasie, were in their queenly glories, and homage paid to them, not only by their colored subjects, but also by a numerous crowd of well-known gentlemen from the city, who go out for curiosity and admiration of certain little yellow amendments to the Constitution.

Here is a description of "Voudous' Day" activity along the lake between Bayou St. John and Lakeport (Milneburg) from the files of the *New Orleans Times* newspaper. A June 23, 1884, edition of the *Times-Democrat* reported Eve of St. John activities: "The queen in attendance" as well as a "scene on the lake coast from Spanish Fort to Milneburg was one which cannot easily be forgotten." (Courtesy Library of Congress.)

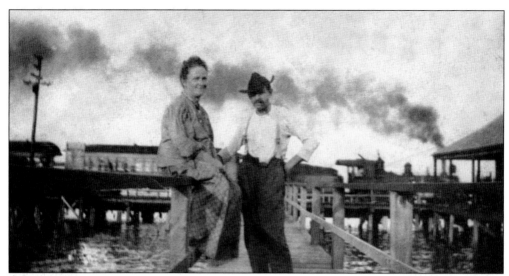

Theresa Gallagher and her second husband, Conrad Freese, pose on the front walk of a camp in Milneburg between 1880 and 1890. The Pontchartrain Railroad's Smokey Mary can be seen in the background. (Courtesy Henry Harmison.)

# PONTCHARTRAIN RAILROAD TIME TABLE
### IN EFFECT
## SUNDAY, MAY 7, 1922, AT 5:00 A. M.

## SUNDAY ONLY

| | NORTH | | | | | SOUTH | | | |
|---|---|---|---|---|---|---|---|---|---|
| Nos. | Leave Pontchartrain Junction | Leave Claiborne Street | Arrive Stern's Factory | Arrive Milneburg | Nos. | Leave Milneburg | Leave Stern's Factory | Arrive Claiborne Street | Arrive Pontchartrain Junction |
| 102 | 5 00a. m. | 5 05a. m. | 5 10a. m. | 5 20a. m. | 101 | -------- | -------- | -------- | -------- |
| 104 | 6 00 | 6 05 | 6 10 | 6 20 | 103 | 5 30a. m. | 5 40a. m. | 5 45a. m. | 5 50a. m. |
| 106 | 7 40 | 7 45 | 7 50 | 8 00 | 105 | 7 00 | 7 10 | 7 15 | 7 20 |
| 108 | 9 00 | 9 05 | 9 10 | 9 20 | 107 | 8 20 | 8 30 | 8 35 | 8 40 |
| 110 | 10 02 | 10 06 | 10 10 | 10 20 | 109 | 9 35 | 9 44 | 9 48 | 9 52 |
| 112 | 11 00a. m. | 11 05a. m. | 11 10a. m. | 11 20a. m. | 111 | 10 30 | 10 40 | 10 45 | 10 50 |
| 114 | 12 01p. m. | 12 05p. m. | 12 10p. m. | 12 20p. m. | 113 | 11 30a. m. | 11 40a. m. | 11 45a. m. | 11 50a. m. |
| 116 | 1 00 | 1 05 | 1 10 | 1 20 | 115 | 12 30p. m. | 12 40p. m. | 12 45p. m. | 12 50p. m. |
| 118 | 2 00 | 2 05 | 2 10 | 2 20 | 117 | 1 30 | 1 40 | 1 45 | 1 50 |
| 120 | 3 00 | 3 05 | 3 10 | 3 20 | 119 | 3 00 | 3 10 | 3 15 | 3 20 |
| 122 | 3 30 | 3 35 | 3 40 | 3 50 | 121 | 3 30 | 3 40 | 3 45 | 3 50 |
| 124 | 4 00 | 4 05 | 4 10 | 4 20 | 123 | 4 00 | 4 10 | 4 15 | 4 20 |
| 126 | 4 30 | 4 35 | 4 40 | 4 50 | 125 | 4 30 | 4 40 | 4 45 | 4 50 |
| 128 | 5 00 | 5 05 | 5 10 | 5 20 | 127 | 5 00 | 5 10 | 5 15 | 5 20 |
| 130 | 5 30 | 5 35 | 5 40 | 5 50 | 129 | 5 30 | 5 40 | 5 45 | 5 50 |
| 132 | 6 00 | 6 05 | 6 10 | 6 20 | 131 | 6 00 | 6 10 | 6 15 | 6 20 |
| 134 | 6 30 | 6 35 | 6 40 | 6 50 | 133 | 6 30 | 6 40 | 6 45 | 6 50 |
| 136 | 7 00 | 7 05 | 7 10 | 7 20. | 135 | 7 00 | 7 10 | 7 15 | 7 20 |
| 138 | 7 30 | 7 35 | 7 40 | 7 50 | 137 | 7 30 | 7 40 | 7 45 | 7 50 |
| 140 | 8 00 | 8 05 | 8 10 | 8 20 | 139 | 8 00 | 8 10 | 8 15 | 8 20 |
| 142 | 8 30 | 8 35 | 8 40 | 8 50 | 141 | 8 30 | 8 40 | 8 45 | 8 50 |
| 144 | 9 00 | 9 05 | 9 10 | 9 20 | 143 | 9 00 | 9 10 | 9 15 | 9 20 |
| 146 | 10 00 | 10 05 | 10 10 | 10 20 | 145 | 9 30 | 9 40 | 9 45 | 9 50 |
| 148 | 11 00p. m. | 11 05p. m. | 11 10p. m. | 11 20p. m. | 147 | 10 30 | 10 40 | 10 45 | 10 50 |
| | | | | | 149 | 11 30a. m. | 11 40p. m. | 11 45p. m. | 11 50p. m. |

By 1922, New Orleanians were riding the famous Smokey Mary out to Milneburg, which by then included not only camps but also hotels, restaurants, roadhouses, shooting galleries, bathing facilities, and fishing piers. Early jazz music was a popular attraction at Milneburg's bandstands, dance halls, and taverns. Sidney Bechet, Louis Armstrong, and Danny Barker were just a few of the jazz greats who performed in Milneburg. (Courtesy New Orleans Public Library.)

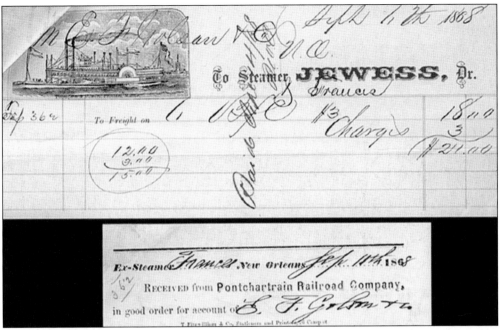

Travel by steamboat began on Lake Pontchartrain around 1815. Pictured are receipts from the steamers *Jewess* and *Frances* written in 1868. (Courtesy New Orleans Public Library.)

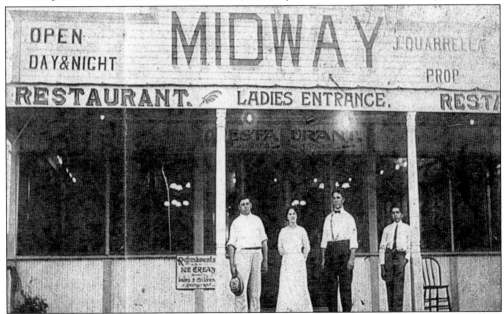

This *c.* 1914 photograph includes, from left to right, Gennaro "John" Quarrella; his wife, Marie Bonano; Gennaro's brother, Joseph Quarrella; and Mr. Conti, the bartender. John Quarrella's business card included: "Eat at the Midway Restaurant & Saloon . . . Milneburg, (On the Pier) . . . DANCING AND ENTERTAINING EVERY DAY AND NIGHT . . . MIDWAY FAMILY BATH HOUSE . . . Regular Bathing Costumes . . . ALSO CAMPS TO RENT . . . All Trains Stop at the Door . . . Phone Hem. 2071." (Courtesy descendants of Gennaro "John" Quarrella and Marie Bonano.)

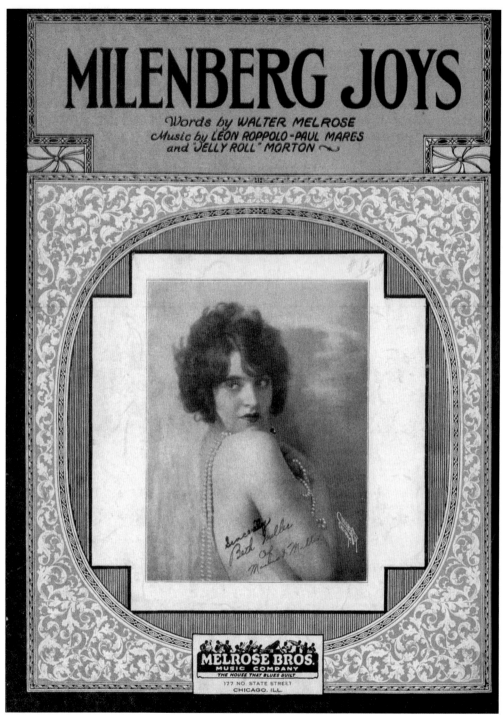

According to Jelly Roll Morton, Walter Melrose (his publisher) "inserted words to some of my hit tunes without my knowledge or permission" (including "Milenberg Joys"). This sheet music was produced by Melrose Brothers of Chicago. (Courtesy Indiana University Sheet Music Collection)

Henry Harmison shared this photograph of his grandmother Anna Bomati Latino (center front) and grandfather Frank Latino (center rear) on the front run of a camp in Milneburg during the early 1900s. (Courtesy Anne Harmison and Henry Harmison.)

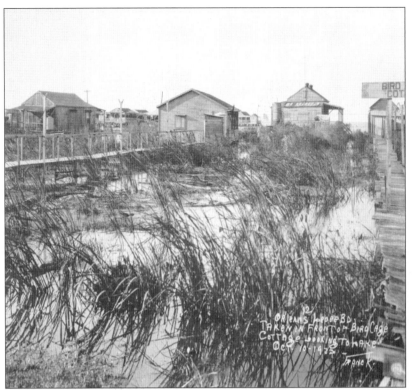

This is a view of the Milneburg camps in 1923. Most camps were named by their owners. To the far right, a portion of the sign for the Birdcage Cottage can be seen. Note that each camp has a cistern to collect rain water. (Courtesy New Orleans Public Library.)

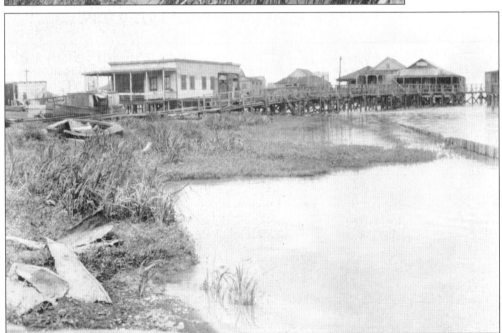

Milneburg camps are pictured in 1927. This area would be reclaimed and replaced with a small church. The photograph was captioned "View looking west from a point about 500' north of road and about 100 ft. west of tracks—Milneburg. Gage—22.5 C. D., 4–18–27, (O. L. B. Orleans Levee Board)—188." (Courtesy New Orleans Public Library.)

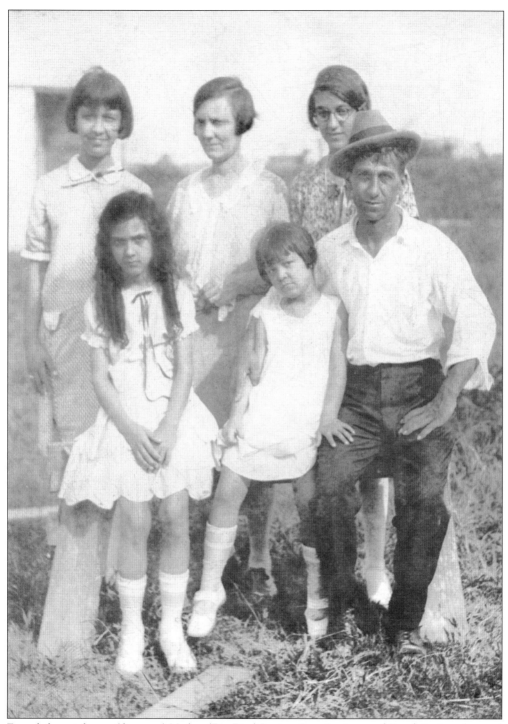

From left to right are (first row) Verlyn (DeeDee) Latino, Jean Latino, and Frank Latino; (second row) Norma Latino Harmison, Anna Bomati Latino, and Mercedes Latino near Arthur Bomati's camp at Milneburg. (Courtesy Anne Harmison and Henry Harmison.)

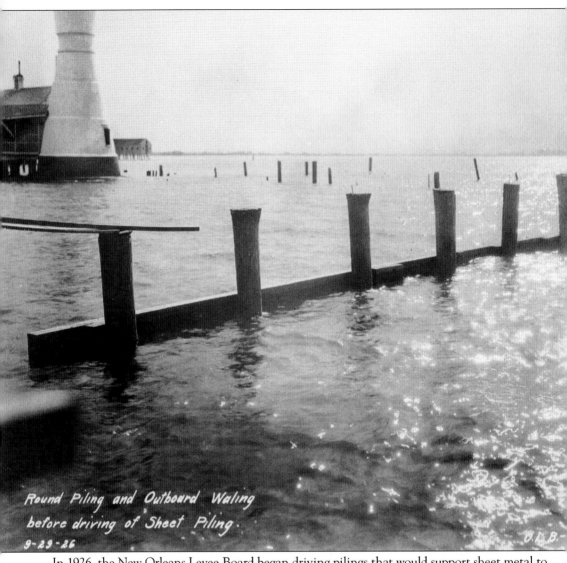

*Round Piling and Outboard Waling before driving of Sheet Piling.*
*9-23-26*
*O.L.B.*

In 1926, the New Orleans Levee Board began driving pilings that would support sheet metal to be filled to reclaim land along the lakeshore at Milneburg. Within a few years, the Milneburg Light would be on dry land surrounded by the Pontchartrain Beach amusement park. The land reclamation resulted in the end of Milneburg as a treasured lakeside summer spot. (Courtesy New Orleans Public Library.)

# *Three*

# WEST END

During the 1830s, another canal was dug to connect New Orleans near the river to the lake. The New Basin Canal (formally known as the New Orleans Navigation Canal) allowed smooth sailing from the city to West End. Irish immigrants were employed as laborers in digging this waterway through mosquito-infested swamps, where they were susceptible to yellow fever, malaria, and cholera. Thousands of laborers died while toiling in the canal, many of them buried where they fell. A monument to them now stands on the neutral ground between West End and Pontchartrain Boulevards near the lake. It reads, "In memory of the Irish immigrants who dug the New Basin Canal 1832–1838 this Celtic Cross carved in Ireland has been erected by the Irish Cultural Society of New Orleans."

A shell road was built along the city side of the New Basin Canal allowing carriages and street cars to transport city dwellers to the lakefront, where they would find Mannessier's Pavilion, the West End Hotel, the Capitol Hotel, Lecourt's Hotel, restaurants, bathhouses, and the Southern Yacht Club. West End, also known as Lake End and New Lake End, provided New Orleanians with yet another source of lakefront entertainment and relaxation.

In 1869, the New Orleans and Metairie Railroad Company extended its Canal Street track from the cemeteries to West End. Between 1871 and 1880, land was reclaimed at the end of the New Basin Canal. By the late 1800s, the area was well developed and included a park and gardens, a bandstand, and amusement rides. The first movie in New Orleans was shown on an outdoor screen on the lakefront. In 1896, Allen B. Blakemore, an electrical engineer for the New Orleans City and Lake Railroad, used the current from the streetcar line to power a vitascope machine.

Bucktown, the area of Metairie bordering the western boundary of New Orleans, developed during the late 1800s and remained a rustic fishing village well into the 20th century. By the late 1800s, camps lined the Seventeenth Street Canal, while the small community boasted a school, a jail, stores, saloons, gambling houses, clubhouses, dance halls, and many restaurants. Many of the camps, including the popular Sid-Mar's Restaurant, still remained until Hurricane Katrina washed them away.

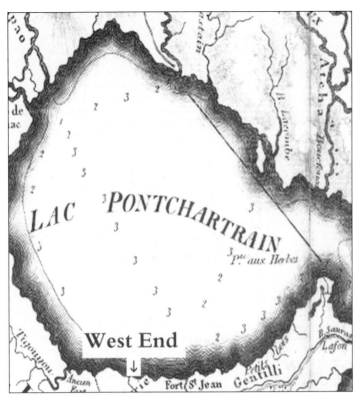

West End

Both maps indicate the location of West End. Above is a view of the entire lake. Below West End's proximity to Spanish Fort is shown. (Courtesy Louisiana Digital Library.)

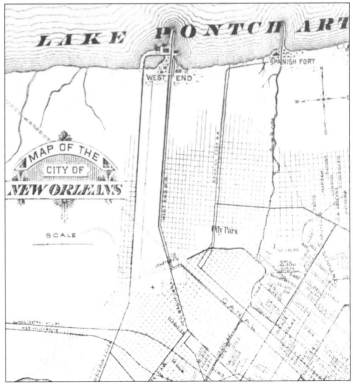

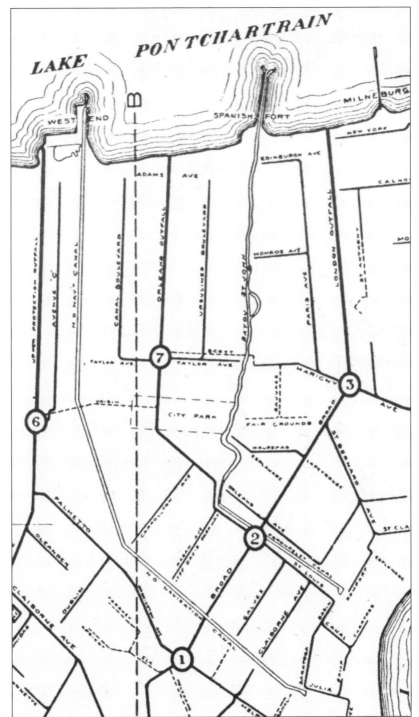

The opening of the New Basin Canal to West End in 1838 allowed the area to thrive as an additional resort and entertainment venue. This 1919 map shows the new canal (labeled N. O. Navigation Canal) as well as the older Carondelet Canal, which led to Bayou St. John. (Courtesy Library of Congress.)

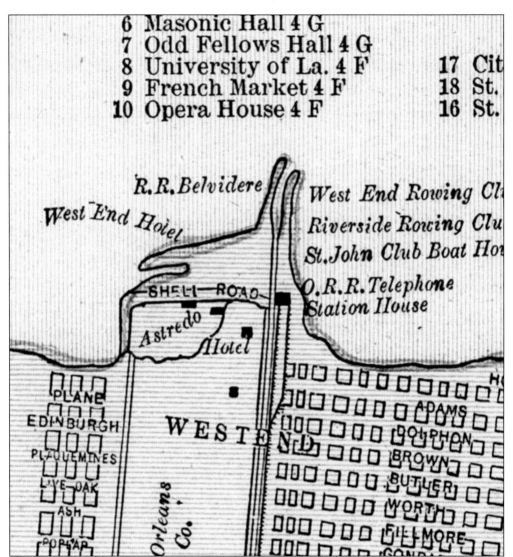

6 Masonic Hall 4 G
7 Odd Fellows Hall 4 G
8 University of La. 4 F          17 Cit
9 French Market 4 F          18 St.
10 Opera House 4 F          16 St.

R. R. Belvidere          West End Rowing Cl
West End Hotel          Riverside Rowing Clu
          St. John Club Boat Ho
SHELL ROAD          O. R. R. Telephone
Astredo Hotel          Station House

PLANE
EDINBURGH          WEST END
PLAQUEMINES          ADAMS
LIVE OAK          DUPHON
ASH          BROWN
POPLAR          Orleans Co.          BUTLER
          WORTH
          FILLMORE

This map segment allows a close view of West End structures and features, including the West End Hotel, West End Rowing Club, Riverside Rowing Club, St. John Club boathouse, and the end of the shell road. Adams Avenue would later be named Robert E. Lee Boulevard. (Courtesy Louisiana Digital Library.)

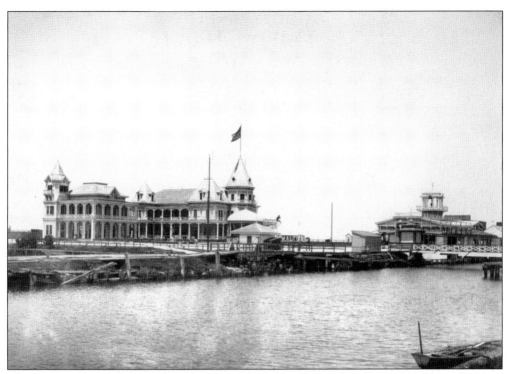

The West End Hotel (left) and large bathhouse (right) are depicted in this *c.* 1900 George Mugnier photograph. The view is from the New Basin Canal. (Courtesy New Orleans Public Library.)

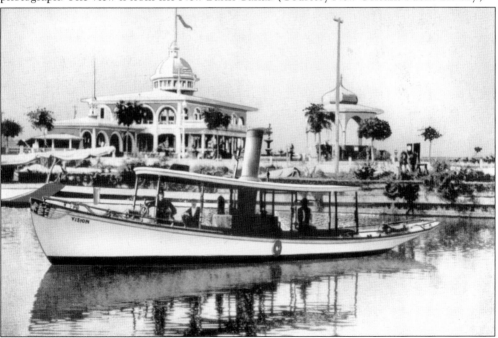

The *Vision* cruises past Mannessier's Pavilion at West End. Fr. Thomas Lorente celebrated the first mass for the parish of St. Dominic at the Pavilion on May 12, 1912. The date of this photograph is not known. (Courtesy New Orleans Public Library.)

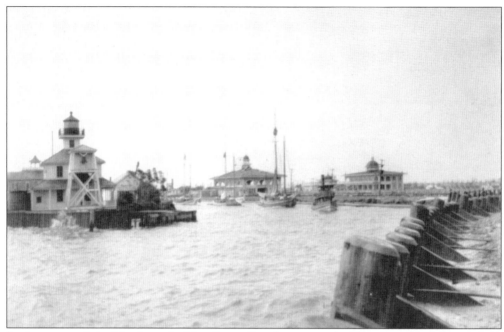

Looking toward the lake from the New Basin Canal, one sees the New Canal Lighthouse (left) a Ferris wheel, schooners and steam-powered vessels, Mannessier's Pavilion, and the West End Hotel (right). This photograph was likely taken during the late 1890s. (Courtesy New Orleans Public Library.)

The Southern Yacht Club, established in 1849 as the second such club in the United States, is pictured in this c. 1900 photograph. The original clubhouse was built in 1879. Viewed here is the second, constructed in 1899. (Courtesy New Orleans Public Library.)

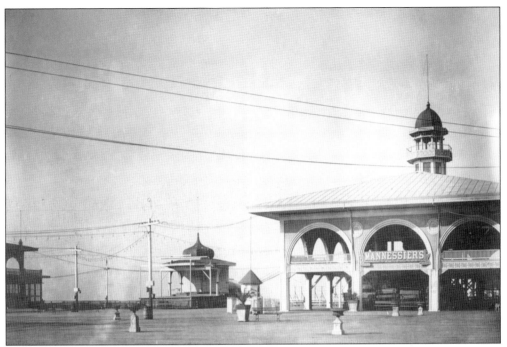

Mannessier's Pavilion is seen at right at West End around 1900. The first Mannessier's, a confectionery famous for its coffee, ice cream, and pastries was located on Royal Street. The pavilion operated at West End from about 1899 to 1911. (Courtesy New Orleans Public Library.)

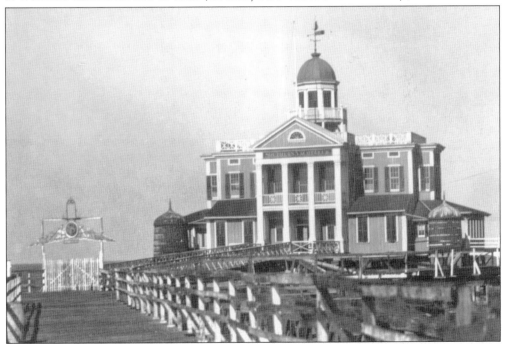

By the late 1940s, this second home of the Southern Yacht Club had deteriorated badly and was replaced with a concrete and steel structure which was used until it was destroyed in the aftermath of Hurricane Katrina. (Courtesy New Orleans Public Library.)

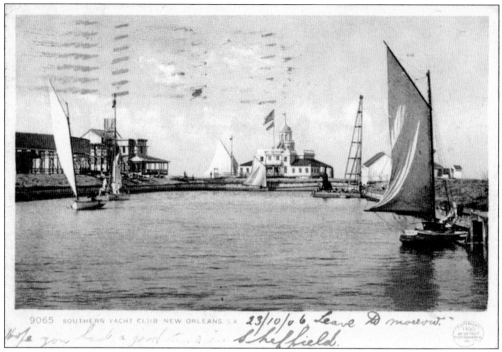

This postcard sent in 1906 depicts the view from the New Basin Canal heading toward the lake. The Southern Yacht Club is in the background. (Courtesy Library of Congress.)

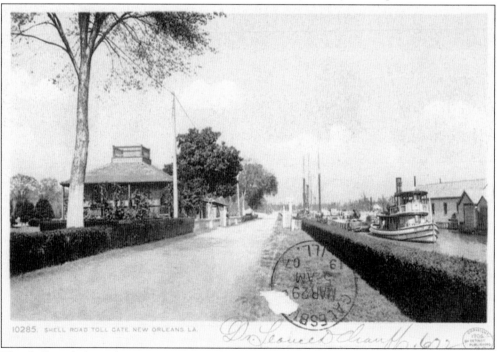

The shell road along the New Basin Canal is depicted in this *c.* 1906 postcard. The road led to West End at Lake Pontchartrain. The back of this postcard reads, "Shell Road Toll Gate, New Orleans, La." The road is now Pontchartrain Boulevard. (Courtesy Library of Congress.)

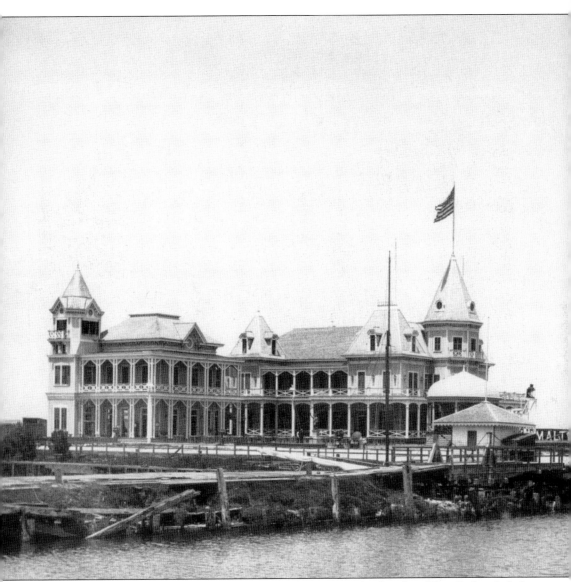

The elegant West End Hotel is depicted in this *c.* 1900 view. Other hotels at West End included the Lake House, the Capitol, and LeCourt's Hotel. None of them remain today. (Courtesy New Orleans Public Library.)

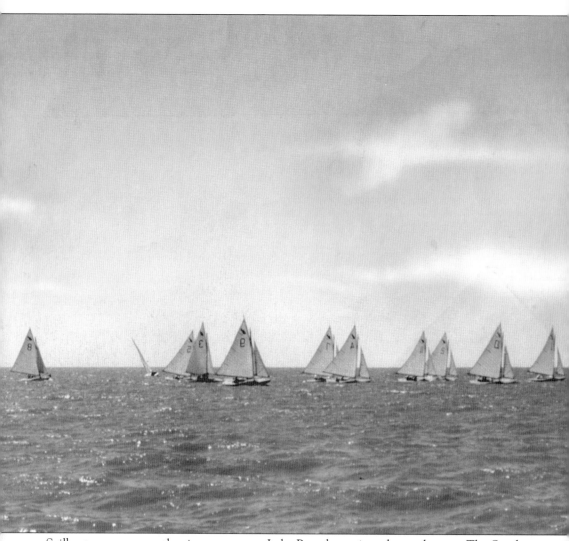

Sailboats pass one another in a regatta on Lake Pontchartrain—date unknown. The Southern Yacht Club held its first regatta on the lake in 1857, after the organization moved from its original headquarters in Pass Christian, Mississippi. (Courtesy New Orleans Public Library.)

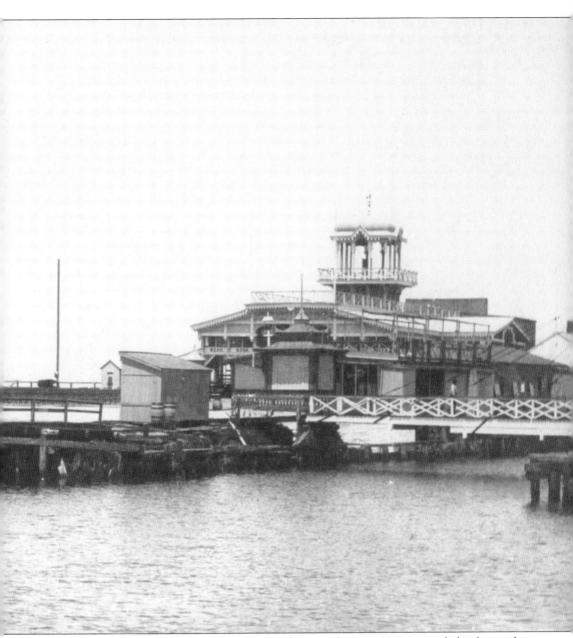

A West End bathhouse is shown in this *c.* 1900 photograph. By 1880, man-made land near the entrance to the New Basin Canal allowed the construction of a park, pathways, a bandstand, pavilions, an opera house, and other attractions. (Courtesy New Orleans Public Library.)

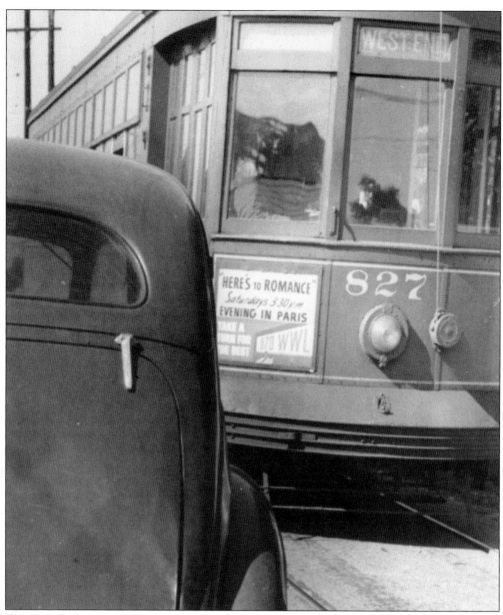

The West End streetcars ran from the intersection of Canal and Carondelet Streets to the lake along the New Basin Canal. The West End Line developed from the New Orleans and Carrollton Railroad, which was established in 1831. The West End cars last ran in 1950. This photograph was taken in 1944. (Courtesy New Orleans Public Library.)

Bucktown has a colorful history dating back to the late 1800s. Gambling and sporting houses were wide open in this area of Jefferson Parish long after they were prohibited in the city.

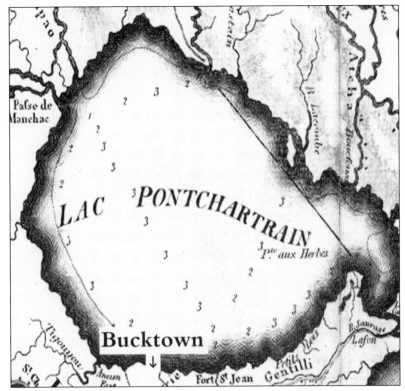

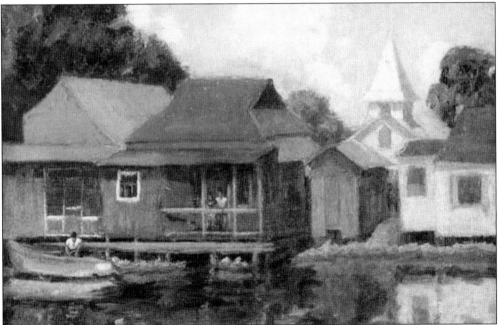

Since the early 1900s, camps lined the infamous Seventeenth Street Canal and the lakefront on the edge of West End. In recent years, the camps had slowly disappeared, but the fishing boats docked in the canal gave Bucktown an old-time charm. Since Hurricane Katrina, the boats are gone. (Courtesy Ogden Museum of Southern Art).

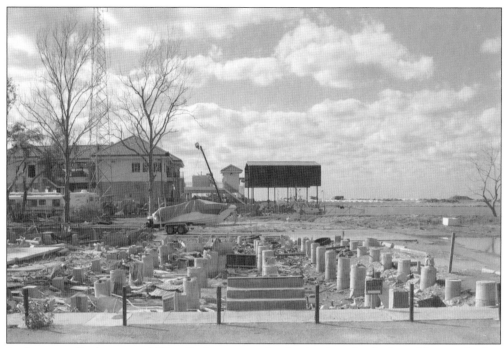

In days past, Bucktown and West End were popular destinations for fresh and live seafood as well as for dining in the many restaurants. Pictured is the foundation of Sid-Mar's Restaurant in Bucktown—all that remained after Hurricane Katrina. (Courtesy Wikipedia.)

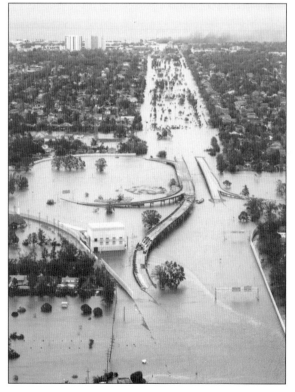

In the days following Hurricane Katrina, levees and flood walls broke, resulting in catastrophic flooding of the Greater New Orleans area. Here the Southern Yacht Club burns (rear center), while the surrounding areas are inundated. The Seventeenth Street Canal runs down the center of this photograph. (Courtesy Wikipedia.)

*Four*

# BACK TO THE BAYOU

The fort on Bayou St. John was decommissioned in 1823 and is best remembered as "Spanish Fort," a term used today to describe the crumbling remains of the ancient structure that was for a time surrounded by an amusement park and resort. By the 1870s, Spanish Fort had become known throughout the United States, as its proprietors billed it as the "Coney Island of the South" (West End also claimed that title). At the pavilion, noted figures of the day spoke and lectured. The resort included the Pontchartrain Hotel, a casino, an opera house, a theater, restaurants, gardens, and bathing piers. In 1896, the East Louisiana Railroad constructed a wharf and trestle for the steamer *Cape Charles*, which ran to and from Mandeville.

During the Civil War, private boats as well as commercial ships and steamers were used on the river and on the lake to deliver provisions needed by the Confederacy. The CSS *Carondelet*, which was built at Bayou St. John, and the yacht *Corypheus* were among those so employed on Lake Pontchartrain. A confederate submarine, believed to be one of the first ever built, was constructed at Spanish Fort in 1861–1862. It sunk while being tested in Bayou St. John, resulting in the loss of three sailors' lives. It was later dredged and displayed near the Over the Rhine at the Spanish Fort resort.

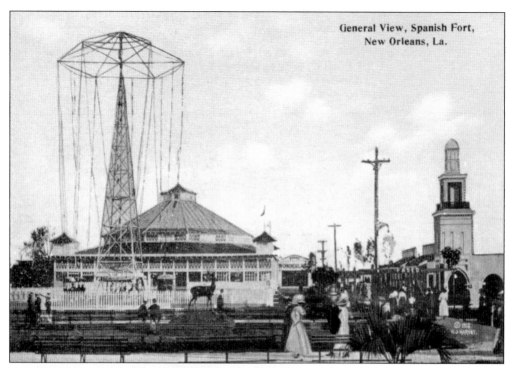

General View, Spanish Fort, New Orleans, La.

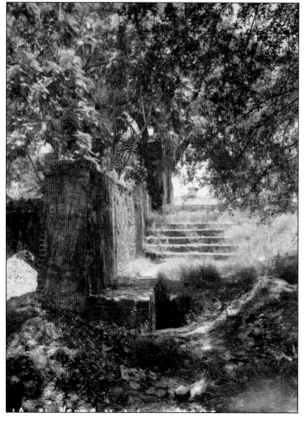

After being decommissioned, Spanish Fort was sold to a private investor who used the property for a lakefront resort and amusement area. It passed through several owners before closing in 1926 to make way for the lakefront land reclamation, which left it offshore. The resort is pictured while it was being touted as "The Coney Island of the South." (Courtesy New Orleans Public Library.)

This 1934 photograph shows the entrance to the old fort. One could view the Spanish Fort Resort from the top of these steps. (Courtesy Library of Congress.)

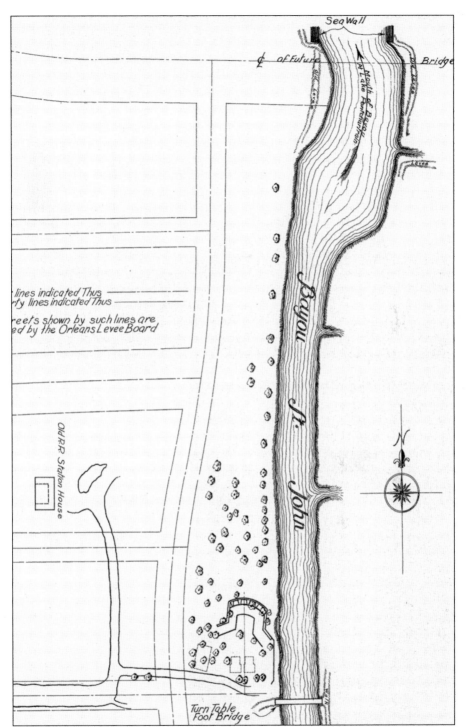

This section of a 1934 survey of historic American Buildings includes a view of the new seawall and reclaimed land as well the outline of streets "proposed by the Orleans Levee Board," the "Old RR [railroad] Station House" (left), the fort (bottom center), and a "Turn Table Foot Bridge" crossing the bayou (bottom). (Courtesy Library of Congress.)

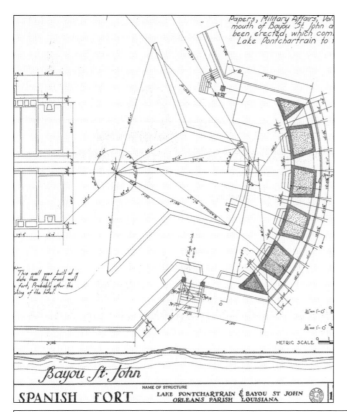

This drawing of the fort shows the structure's proximity to Bayou St. John, which actually runs north to south. The note near the bottom left reads, "This wall was built at a later date than the front wall of the fort, probably after the demolishing of the hotel." (Courtesy Library of Congress.)

*Notes*

The walls of the fort are of solid common brick resting on cypress grillage footings and beds of clam shells. The space between the two walls accross the front is back-filled with dirt and brick bats.

Units shown behind main fort are the foundations of Buildings of a later date than the fort. These foundations are now in a ruined state and their tops are from 6" to 4'-0" below the present grade.

The outside walls of the fort and the Building foundations are laid in mortar made from burned and crushed clam shells.

Foundations of buildings built at a later date, which are also now in ruins, are shown on sheet No.

The front walls of the present fort are probably those erected between 1807 & 1809; mentioned in "Amer. State Papers, Military Affairs," Vol. 1, P. 236. as follows: At the mouth of Bayou St. John a strong new battery has been erected; which commands the passage from Lake Pontchartrain to the city of New Orleans

The surveyor's notes can be seen in this section of the 1934 historic American Buildings survey. (Courtesy Library of Congress.)

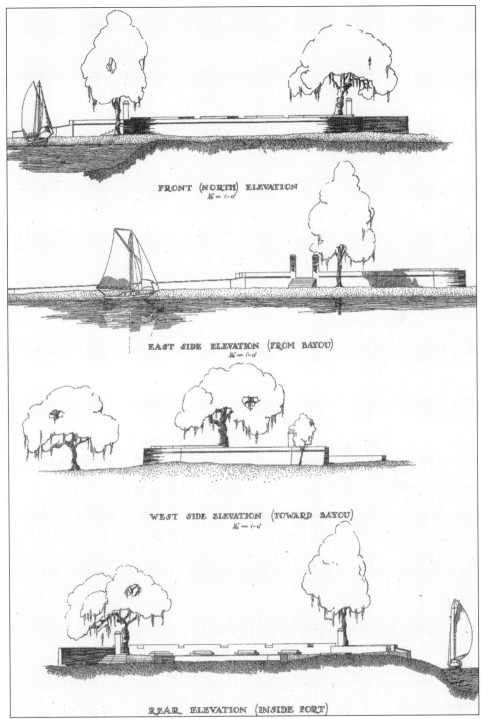

FRONT (NORTH) ELEVATION
⅛" = 1'-0"

EAST SIDE ELEVATION (FROM BAYOU)
⅛" = 1'-0"

WEST SIDE ELEVATION (TOWARD BAYOU)
⅛" = 1'-0"

REAR ELEVATION (INSIDE FORT)

Here all four views of the fort as surveyed in 1934 are seen: the first (top) from the north, as viewed from the lake side; the second is the east elevation as seen from the bayou; the third is the west side elevation, looking toward the bayou, and the last, (bottom) the rear view looking toward the lake. (Courtesy Library of Congress.)

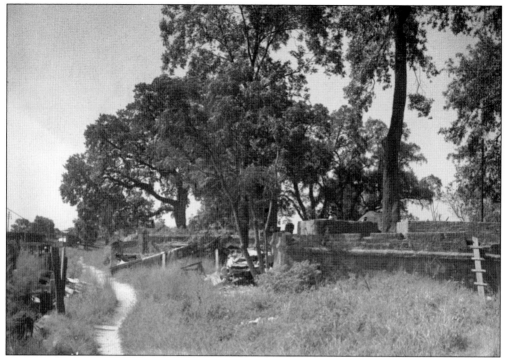

The front wall of Spanish Fort is seen as it faced the lake in 1934. Note that by this time, it was surrounded by land due to reclamation projects. (Courtesy Library of Congress.)

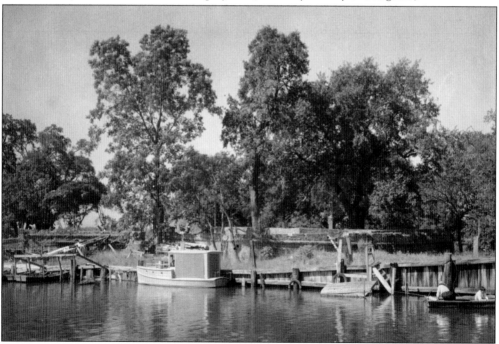

Another 1934 view of the fort (in the background) looks west across Bayou St. John. At this time, the bayou was still used as a minor navigation route. It was declared non-navigable in 1936. (Courtesy Library of Congress.)

By the 1870s and 1880s, a railroad line made a ride from the city to the lake relatively easy. This 1919 advertisement for Spanish Fort amusement park touts "Spacious Picnic Grounds" and invites guests to "bring the kiddies . . . It'll be of benefit to every member of the family." (Courtesy Wikipedia.)

Spanish Fort affords an ideal camping spot for the entire family. Come, bring the kiddies and make yourself at home for the day. It'll be of benefit to every member of the family.

The dancing floor at Spanish Fort leaves nothing to be desired. Newly laid, and highly polished, you glide away to the strains of well rendered music by Paoletti's Band.

The Spanish Fort pavilion, hosted band concerts and lectures. This 1919 advertisement announces a concert with "strains of well rendered music by Paoletti's Band" in the "Model Dancing Pavilion." (Courtesy Wikipedia.)

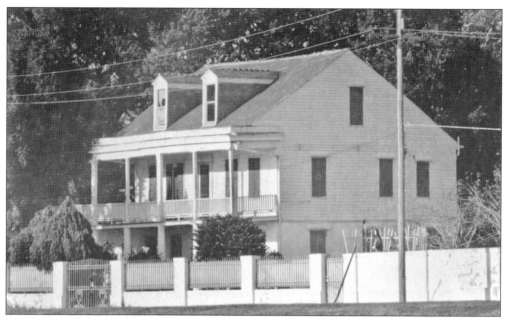

The historic Fernandez-Tissot House at 1400 Moss Street is pictured. It was built around 1850 along the bayou. In 1964, when this photograph was taken, it was used as the convent of the Missionary Sisters of the Sacred Heart. It stands on the grounds of Cabrini High School. The house is also pictured on page 64. (Courtesy Library of Congress.)

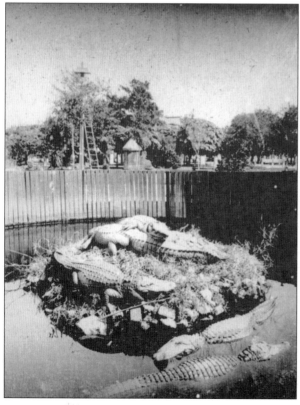

The alligator pen at Spanish Fort was a popular attraction. This 1880 view includes the sign on the pen that reads "Do Not Throw Anything At The Alligators." (Courtesy New Orleans Public Library.)

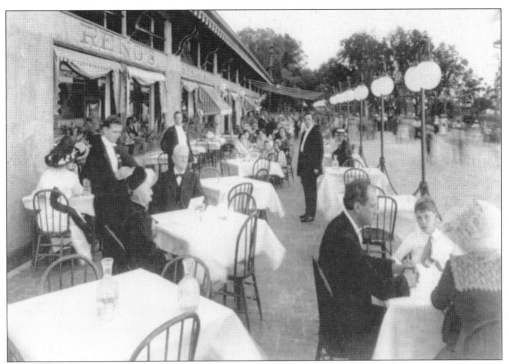

Many fine restaurants welcomed diners to Spanish Fort. Reno's is shown here in both day and evening views. Other Spanish Fort visitors can be seen on the right in the top photograph. (Courtesy Library of Congress.)

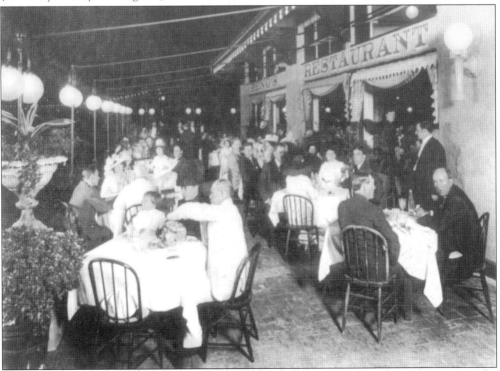

By 1919, according this advertisement, "the entire Park has been rejuvenated" and includes Tranchina's "GOOD RESTAURANT" with a band "Conducted by Terry Tranchina, in the pavilion overlooking the lake." The resort offered "Boating and bathing" in "the finest playground in the south. Situated on the banks of Lake Pontchartrain." The ad boasted, "14, 880 people visited Spanish Fort last Sunday." (Courtesy Wikipedia.)

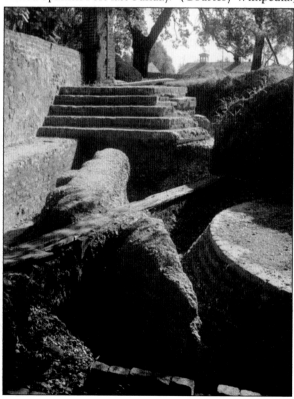

During the 1934 Historic American Buildings Survey, three periods of construction were revealed at the fort. What is now called Spanish Fort was originally built by the French, strengthened by the Spanish, and rebuilt by the United States. (Courtesy Library of Congress.)

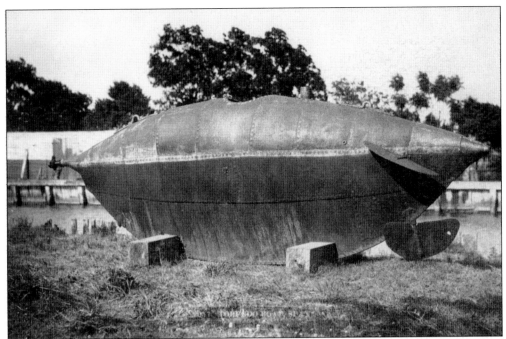

According to the February 15, 1868, *New Orleans Picayune* morning edition, "A torpedo boat, which was built in this city . . . is to be sold at public auction today." It "was sunk in the [Bayou St. John] canal . . . in 1862." The *Picayune* afternoon edition stated that the torpedo boat was sold as scrap for $43. It was later located to the Spanish Fort resort (above). From 1942 to 1953, the submarine was on display in Jackson Square. (Courtesy New Orleans Public Library.)

Spanish Fort is pictured in 1941, after Works Progress Administration (WPA) improvements, which included paved drives, walks, and landscaping. By this time, few traces of the old resort remained. (Courtesy New Orleans Public Library.)

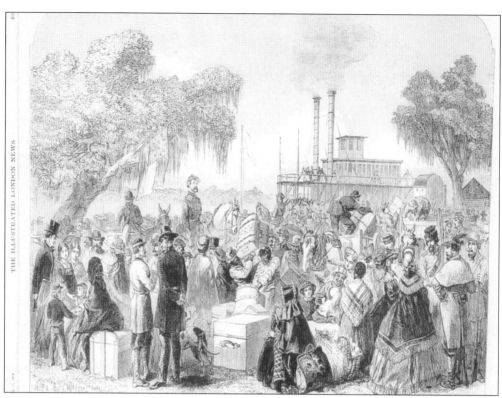

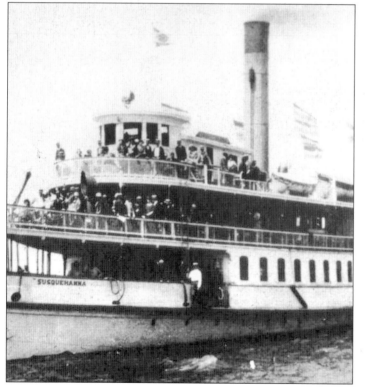

This photograph and an accompanying article entitled "Federalists Evacuating Civilians from Lake Pontchartrain, Louisiana in 1863 during the America Civil War" were published in the *Illustrated London News* (ILN) on April 11, 1863. (Courtesy Lewis H. Beck Center for Electronic Collections and Services, Emory University.)

The steamer *Susquehanna* makes it way from the north to the south shore. Operated by the Lake Transit Company, the steamer took as long as two hours to cross the lake. (Courtesy Library of Congress.)

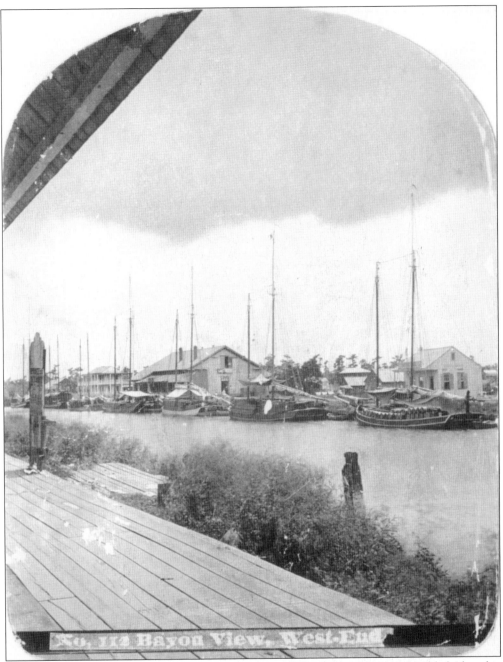

This photograph shows a c. 1900 "Bayou View, West-End" by George Mugnier. It is likely that this caption should read "Bayou View, Bayou St. John." What appears to be the historic pilot house can be seen in the left center. (Courtesy New Orleans Public Library.)

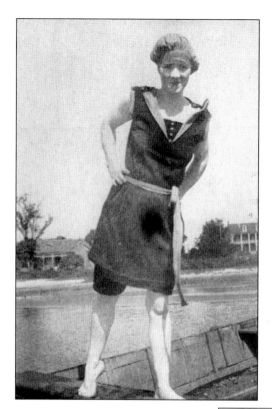

Constance "Tiny" Corcoran Adorno, born and raised in New Orleans, enjoys the bayou not far from her family's Moss Street home around 1910. Note the historic Fernandez-Tissot House at 1400 Moss Street (described on page 58) in the right center. Thanks go to Connie Adorno Barcza for sharing this photograph of her grandmother.

This bird's-eye view of Spanish Fort dates from the early 1900s. By this time, Spanish Fort was known throughout the United States. Noted Speakers appearing there included author William Makepeace Thackeray, Gen. Ulysses S. Grant, and playwright Oscar Wilde. (Courtesy New Orleans Public Library.)

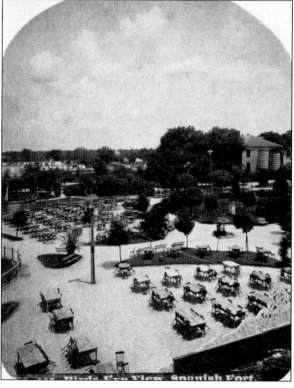

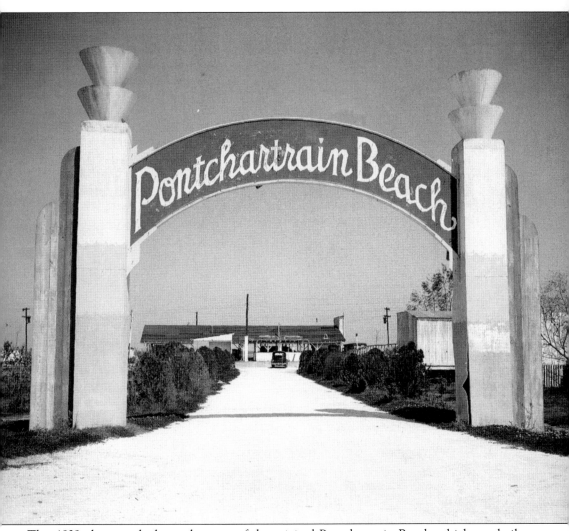

This 1939 photograph shows the gates of the original Pontchartrain Beach, which was built opposite Spanish Fort along Bayou St. John in 1928. This photograph was taken shortly before the amusement park moved eastward to newly reclaimed land fronting old Milneburg. (Courtesy New Orleans Public Library.)

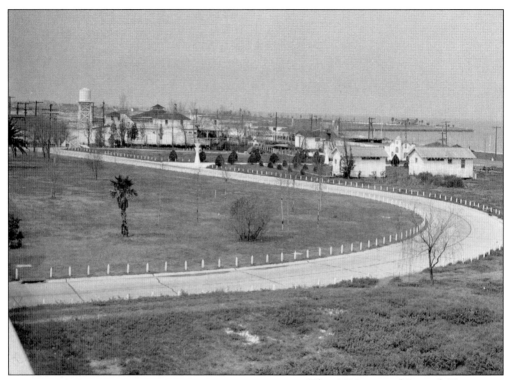

This 1939 view of Spanish Fort amusement park was taken shortly before it was demolished. The steps of the newly constructed seawall can be viewed in the distance on the right. (Courtesy New Orleans Public Library.)

By the 1940s, the seawall stretched from West End to the Lakefront Airport. The old Spanish Fort is now offshore by approximately one half-mile. (Courtesy New Orleans Public Library.)

*Five*

# LIGHTHOUSES

Seven lighthouses once illuminated the ports and passages of Lake Pontchartrain. It is somewhat amazing that the remains of all but two still survive in some form.

The Bayou St. John Light (also known as the Port St. John Light) was established in 1811 on the lake at the bayou. It no longer exists.

The first Port Pontchartrain Light at Milneburg was built in 1832. The existing structure was built in the lake in 1855 but is now surrounded by the University of New Orleans Technology Center, after having served time as a fixture on the grounds of the Pontchartrain Beach property.

The Pass Manchac Light on the western shore was established in 1837 and replaced in 1857. It was damaged in the storms of 1888, 1890, 1915, 1926, and 1931. It was deactivated in 1987.

In 1838, the New Canal Light was established and located at West End on the entrance of the New Basin Canal. A second was built in 1855 and a third, the existing light, was constructed in 1890. Badly damaged during Hurricane Katrina and again in Hurricane Rita, it barely survives after having been toppled.

The Tchefuncte River Light at the mouth of the river at Madisonville on the north shore was also constructed in 1838. It was replaced in 1868, after being heavily damaged during the Civil War, using the original bricks and foundation. It also survived the storm of 2005. The keeper's house (built in 1887) was relocated in 2003 to the grounds of the Lake Pontchartrain Basin Maritime Museum.

On the northeastern shore, the Bayou Bon Fouca Light was established in 1848. The Confederate army burned it in 1862. It was replaced by the Pointe Aux Herbes Light (farther south near Slidell) in 1875 and deactivated in 1945. The lighthouse was burned by vandals during the 1950s, but the foundation survives. Also in the east, the West Rigolets Lighthouse was built in 1855. It was in disrepair for many years until it was completely destroyed by Hurricane Katrina in 2005.

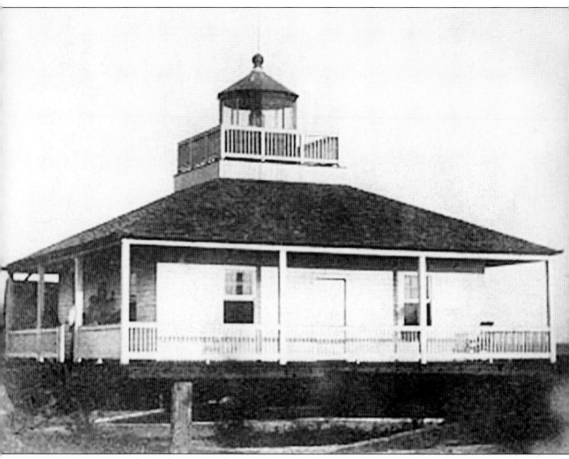

The Bayou St. John Light was the first lighthouse built in America outside the 13 original colonies. The station was established on Bayou St. John at the lake in 1811. The original lighthouse was destroyed by a storm in 1837. In 1838, a new, 48-foot tower was constructed. By 1855, a cottage-type structure on pilings replaced the older lighthouse. The light was deactivated in 1878. It no longer exists. (Courtesy U.S. Coast Guard.)

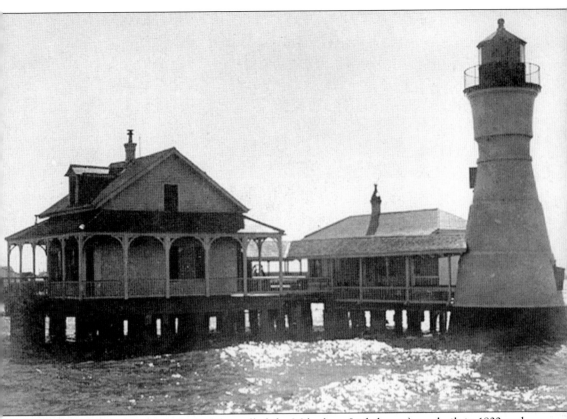

The first Port Pontchartrain Light (also called the Milneburg Lighthouse) was built in 1832 and was replaced with the existing structure (pictured) in 1855. It was damaged during the Civil War but repaired and relighted in 1863. After a 15-foot storm surge killed an estimated 2,000 people in the 1893 hurricane, survivors were cared for and taken in by Ellen Wilson, the female light keeper. The light was deactivated in 1929. Built on piers in the lake with an adjacent keeper's house, it would later be surrounded by concrete in Kiddieland at the Pontchartrain Beach amusement park. Having withstood the ravages of Hurricane Katrina, this century-and-a-half-old structure can now be found in the University of New Orleans Technology Center. (Courtesy U.S. Coast Guard.)

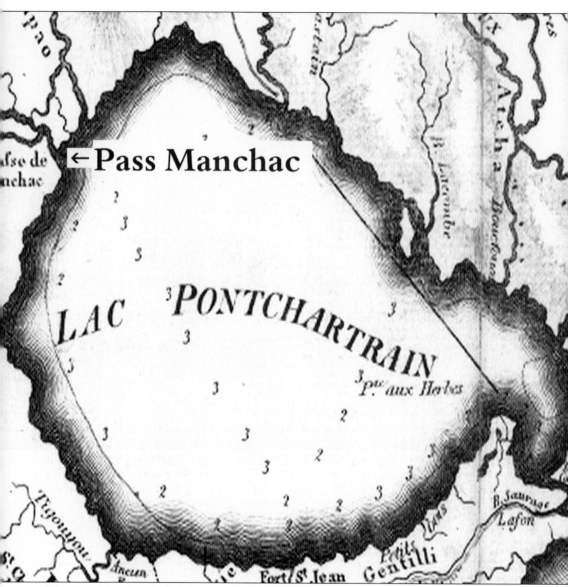

← **Pass Manchac**

The Pass Manchac Light's location on the western shore has left it vulnerable to hurricanes, which damaged it time and time again. When built, the light was on Lake Pontchartrain, but erosion leaves it now off the shore in Pass Manchac. In recent years, pilings were driven around the light in an effort to keep it from leaning. The pilings served to protect it from the ravages of Hurricane Katrina.

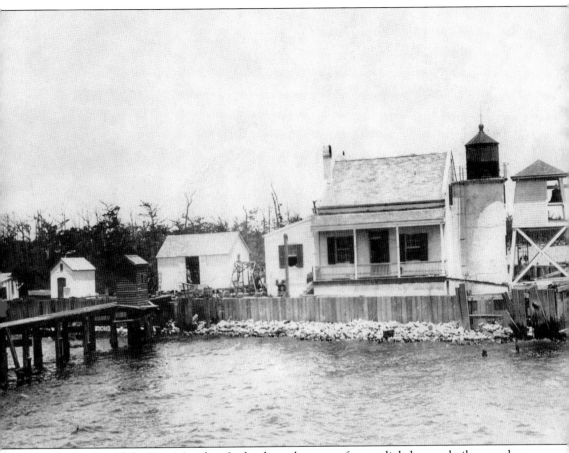

This 1918 view of the Pass Manchac Light shows but one of many lighthouses built near that location. The light was established in 1837 and first lit in 1839. After a series of problems and several replacements, the final light and keeper's house were built in 1857. Confederate soldiers confiscated the lens in 1861 and stored it at the New Canal station until it was recaptured by Union forces. The Pass Manchac Light was deactivated in 1987. (Courtesy U.S. Coast Guard.)

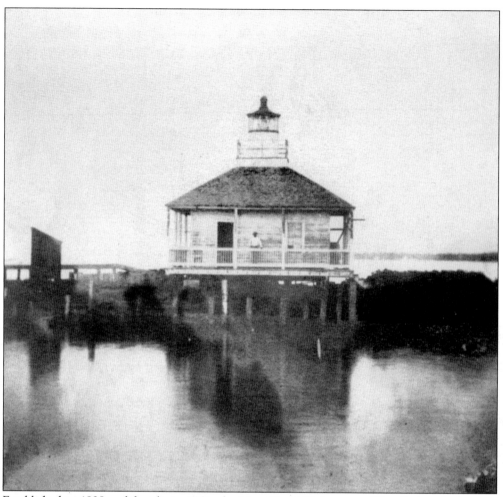

Established in 1838 and first lit in 1901, the New Canal Light sat at West End and what was the entrance to the New Basin Canal. Francis D. Gott was awarded the contract to build this light as well as the Port Pontchartrain and Pass Manchac Lighthouses. In 1855, a new lighthouse (pictured) replaced the original. (Courtesy U.S. Coast Guard.)

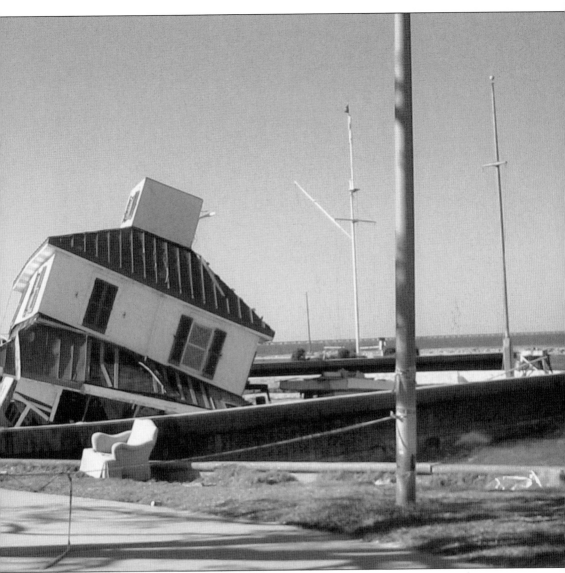

The current West End/New Basin Light was built in 1890 and moved to its current location in 1910. It survived the 1903 Cheniere Caminada storm, when its female keeper, Caroline Riddle, housed survivors there. It was damaged during hurricanes in 1926 and 1927, after which it was raised on concrete piers. In 1936, the breakwater around the station was filled in, placing the light on dry land. During Hurricanes Katrina and Rita in 2005, the lighthouse was badly damaged, and lack of care resulted in it collapsing months after the storms. At the time of this writing, the Lake Pontchartrain Basin Foundation is seeking funding to restore this historic treasure. (Courtesy Wikipedia.)

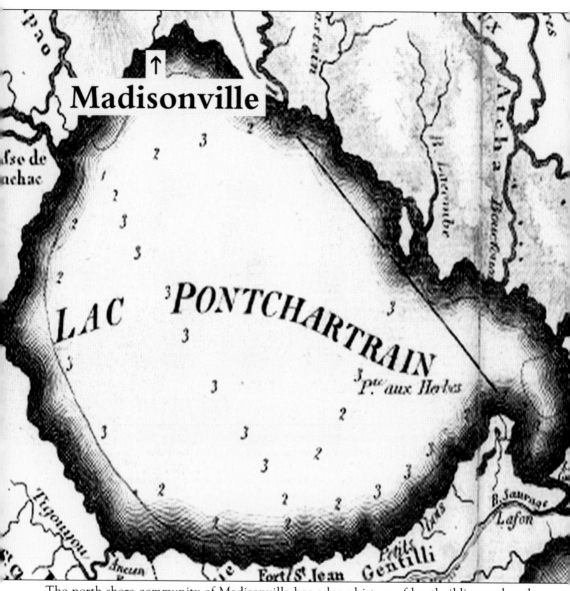

The north shore community of Madisonville has a long history of boatbuilding and trade. This map shows the approximate location of the Tchefuncte River Lighthouse near the shore of Madisonville.

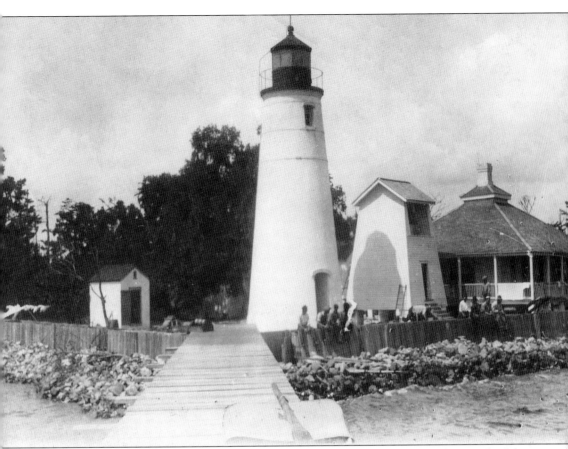

Built in 1838, the Tchefuncte River Lighthouse stands in Lake Pontchartrain at the mouth of the Tchefuncte River. During the Civil War, the light was so badly damaged that it was demolished and replaced in 1868 using the original bricks and foundation. This photograph was taken in 1919. (Courtesy U.S. Coast Guard.)

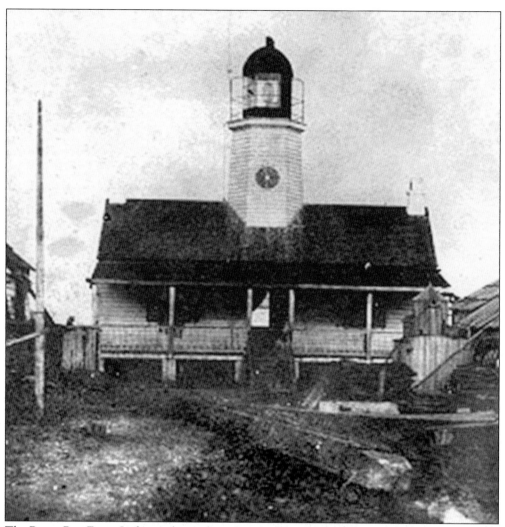

The Bayou Bon Fouca Light was located northwest of the Rigolets and west of the current city of Slidell. It was established in 1848 as a two-story dwelling with a 12-foot tower constructed on the roof. Confederate forces burned the structure down in 1862. (Courtesy U.S. Coast Guard.)

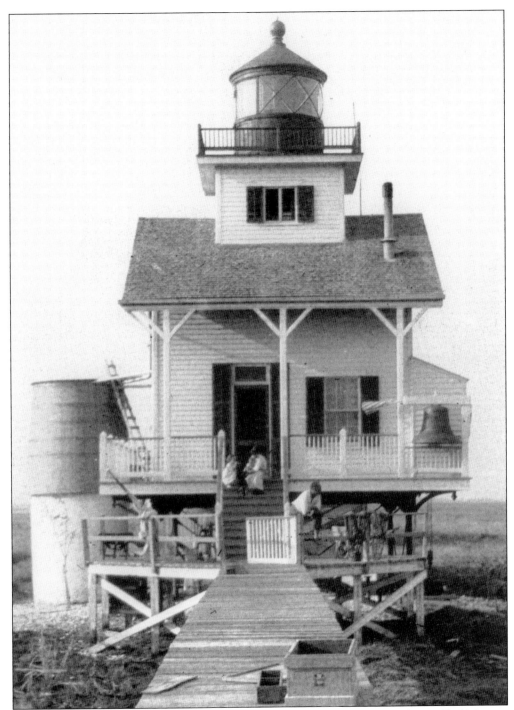

The Rigolets connects Lake Pontchartrain to the Mississippi Sound and the Gulf of Mexico. "Rigolets" comes from the French word *rigole*, which means "trench" or "gutter." The West Rigolets Lighthouse was built in 1855. From 1898 until 1912, Anna M. Read served there as one of the many women lighthouse keepers on Lake Pontchartrain. The light had been in disrepair for many years and was completely destroyed by Hurricane Katrina in 2005. (Courtesy U.S. Coast Guard.)

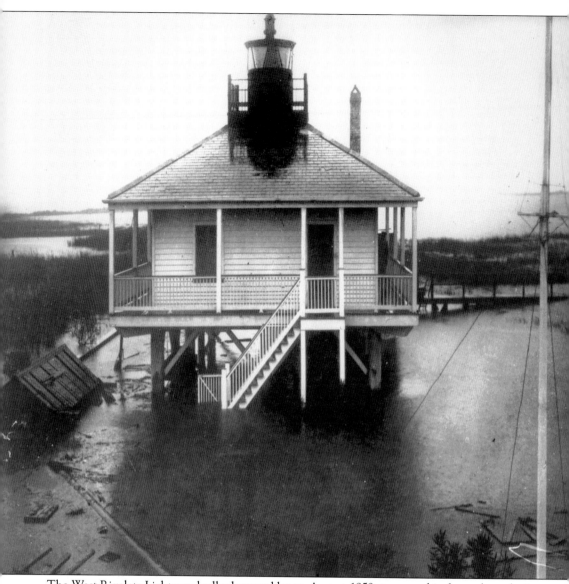

The West Rigolets Light was badly damaged by an August 1859 storm and is shown here during a flood. Its use was discontinued some time around the 1940s. (Courtesy U.S. Coast Guard.)

# *Six*

# LITERATURE

Life on Lake Pontchartrain has been described countless times in writing. In 1852, Harriet Beecher Stowe included a description in *Uncle Tom's Cabin*: "The lake lay in rosy or golden streaks, save where white-winged vessels glided hither and thither." Mark Twain wrote about West End and Spanish Fort in *Life on the Mississippi*.

Kate Chopin apparently enjoyed "The large expanse of water studded with pleasure-boats, the sight of children playing merrily along the grassy palisades, the music." Alice Dunbar said, "Now, a picnic at Milneburg is a thing to be remembered for ever," while Eliza Ripley wrote, "a dinner at 'Lake End' was an occasion." William Faulkner's 1927 novel is not regarded as among his best, but in *Mosquitoes* he wrote about the *Nausikaa*, a yacht docked in the New Basin Canal, and the people who sailed on it. By 2006, Poppy Z. Brite was poking fun at Louisiana gaming laws as they related to gambling boats: "Because the law allowed them to remain in port if sailing conditions were dangerous, the captains came up with all sorts of creative threats to their vessels."

Harriet Beecher Stowe wrote in *Uncle Tom's Cabin* (1852), "At this time in our story, the whole St. Clare establishment is, for the time being, removed to their villa on Lake Pontchartrain . . . to seek the shores of the lake, and its cool sea-breezes. . . . St. Clare's villa was an East Indian cottage, surrounded by light verandahs of bamboo-work, and opening on all sides into gardens and pleasure-grounds . . . where winding paths ran down to the very shores of the lake, whose silvery sheet of water lay there, rising and falling in the sunbeams,—a picture never for an hour the same, yet every hour more beautiful. . . . It is now one of those intensely golden sunsets which kindles the whole horizon into one blaze of glory, and makes the water another sky. The lake lay in rosy or golden streaks, save where white-winged vessels glided hither and thither, like so many spirits, and little golden stars twinkled through the glow, and looked down at themselves as they trembled in the water." (Courtesy Library of Congress.)

"The evening was so soft as to tempt her and a party of congenial spirits to a ride over the shell road—that famous avenue, bordered with groves, and which terminated a few miles from New Orleans, at Lake Pontchartrain. . . . Arrived at the lake, a supper of wines and costly dishes was ordered, which it was thought would add to the hilarity of the party," wrote Napier Bartlett in 1863 in *Clarimonde: a Tale of New Orleans Life and of the Present War.* (Courtesy Project Gutenberg.)

In 1874, Mark Twain wrote in *Life on the Mississippi,* "Thence, we drove a few miles across a swamp, along a raised shell road, with a canal on one hand and a dense wood on the other; and here and there, in the distance, a ragged and angular-limbed and moss-bearded cypress, top standing out, clear cut against the sky, and as quaint of form as the apple-trees in Japanese pictures—such was our course and the surroundings of it. There was an occasional alligator swimming comfortably along in the canal, and an occasional picturesque . . . person on the bank, flinging his statue-rigid reflection upon the still water and watching for a bite." (Courtesy Project Gutenberg.)

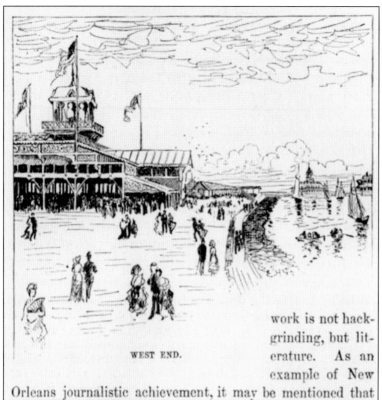

Also from *Life on the Mississippi,* "And by-and-bye we reached the West End, a collection of hotels of the usual light summer-resort pattern, with broad verandas all around, and the waves of the wide and blue Lake Pontchartrain lapping the thresholds. We had dinner on a ground-veranda over the water—the chief dish the renowned fish called the pompano, delicious as the less criminal forms of sin." (Courtesy Project Gutenberg.)

WEST END.

work is not hack-grinding, but literature. As an example of New Orleans journalistic achievement, it may be mentioned that

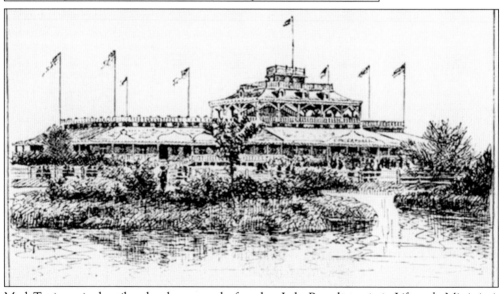

Mark Twain again describes the pleasures to be found on Lake Pontchartrain in *Life on the Mississippi*: "There are good clubs in the city now—several of them but recently organized—and inviting modern-style pleasure resorts at West End and Spanish Fort. Thousands of people come by rail and carriage to West End and to Spanish Fort every evening, and dine, listen to the bands, take strolls in the open air under the electric lights, go sailing on the lake, and entertain themselves in various and sundry other ways." (Courtesy Project Gutenberg.)

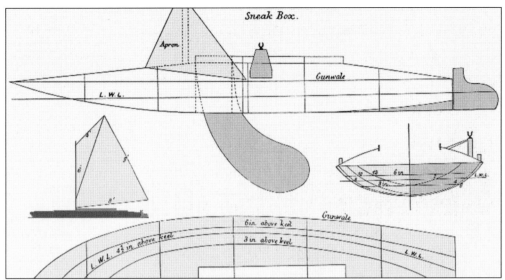

Nathaniel H. Bishop recalls in his 1879 book *Four Months in a Sneak-Box*, "My shortest route to the Gulf of Mexico was through New Basin Canal, six miles in length, into Lake Pontchartrain, and from there to the Gulf. The first part of this canal runs through the city proper, and then through a low swampy region out into the shallow Lake Pontchartrain. At the terminus of New Basin Canal I found a small light-house, two or three hotels, and a few houses, making a little village. . . . Night settled down upon us. . . . Soon the quiet hamlet changed to a scene of merriment . . . people of the city drove out in their carriages to have a 'lark,' . . . which seemed to begin at the hotels with card-playing, dancing . . . and to end in a general carousal." (Courtesy Project Gutenberg.)

Kate Chopin wrote, in 1894's *La Belle Zoraide*, "The summer night was hot and still; not a ripple of air swept over the marais. Yonder, across Bayou St. John, lights twinkled here and there in the darkness, and in the dark sky above a few stars were blinking. A lugger that had come out of the lake was moving with slow, lazy motion down the bayou. A man in the boat was singing a song." (Courtesy New Orleans Public Library.)

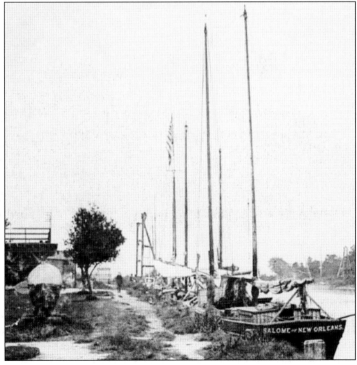

# A NIGHT IN ACADIE

*By KATE CHOPIN*

AUTHOR OF "BAYOU FOLK"

Published by
VVay & VVilliams
CHICAGO

MDCCCXCVII

"One afternoon he took her out to the lake end. She had been there once, some years before, but in winter, so the trip was comparatively new and strange to her. The large expanse of water studded with pleasure-boats, the sight of children playing merrily along the grassy palisades, the music, all enchanted her," Chopin wrote in 1897's *A Night in Acadie*. (Courtesy Project Gutenberg.)

Alice Dunbar's 1899 edition of *The Goodness of St. Rocque* includes the following: "A crowd . . . of Creole girls and boys . . . boarded the ramshackle dummy-train that puffed its way wheezily out wide Elysian Fields Street, around the lily-covered bayous, to Milneburg-on-the-Lake. Now, a picnic at Milneburg is a thing to be remembered for ever. One charters a rickety-looking, weather-beaten dancing-pavilion; built over the water . . . the young folks go up-stairs and dance to the tune of the best band you ever heard. . . . Then one can fish in the lake and go bathing under the prim bath-houses . . . and go rowing on the lake in a trim boat." (Courtesy Project Gutenberg.)

*The* GOODNESS
OF ST. ROCQUE
*AND OTHER STORIES*

By
ALICE DUNBAR-

NEW YORK

New York: DODD, MEAD AND
COMPANY Mdcccxcix

Eliza Ripley recalled in *Social Life in Old New Orleans* (1912): "There was a large hotel (there may be still—it is sixty years since I saw it) mostly consisting of spacious verandas, up and down and all around, at the lake end of the shellroad, where parties could have a fish dinner and enjoy the salt breezes, but a dinner at 'Lake End' was an occasion, not a climax to a shopping trip. The old shellroad was a long drive, Bayou St. John on one side, swamps on the other, green with rushes and palmetto, clothed with gay flowers of the swamp flag. The road terminated at Lake Pontchartrain, and there the restful piazza and well-served dinner refreshed the inner woman." (Courtesy Project Gutenberg.)

SOCIAL LIFE IN
OLD NEW ORLEANS
*Being Recollections of my Girlhood*

BY

ELIZA RIPLEY

ILLUSTRATED

NEW YORK AND LONDON
D. APPLETON AND COMPANY
MCMXII

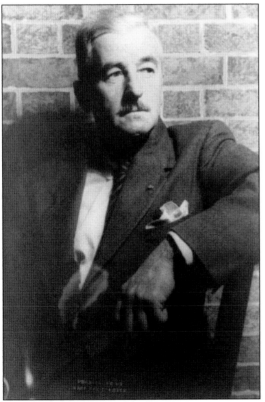

In 1927, William Faulkner, shown in this photograph by Carl Van Vechten, began his novel *Mosquitoes* with "The *Nausikaa* lay in the basin—a nice thing, with her white matronly hull and mahogany-and-brass superstructure and the yacht club flag at her peak. A firm, steady wind blew in from the lake." (Courtesy Wikipedia.)

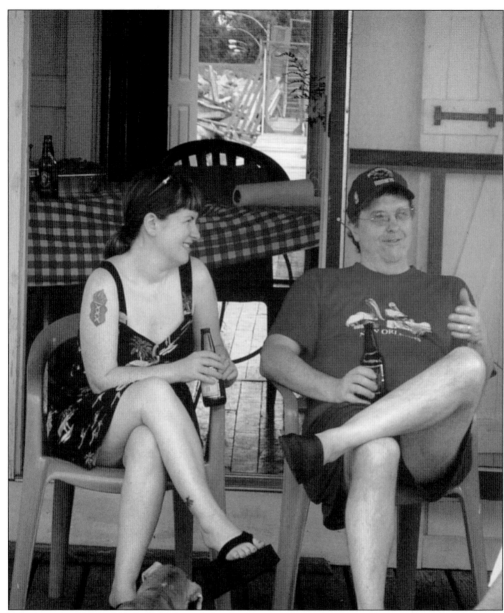

Alluding to an earlier time while describing the present, Poppy Z. Brite wrote in *Soul Kitchen* (2006), "After a long prohibition that would surely have shocked Mark Twain and his poker buddies . . . gambling was relegalized in Louisiana in 1991. . . . Originally all boats had been required to leave their docks and cruise several times a day. None of them wanted to, since gamblers disliked being stuck on the boat for the entire cruise and would disembark before it set sail. Because the law allowed them to remain in port if sailing conditions were dangerous, the captains came up with all sorts of creative threats to their vessels: mysterious debris in the lake, approaching hurricanes as late as Christmas, large flocks of pelicans and other, even more fearsome seabirds." The author is pictured with Chris DeBarr at Camp-a-Nella on the lake.

# Seven

# JAZZ

Jazz was born on the lake just as it was in the city. The introduction to the National Public Radio review of the 20th century's most important American musical works begins, "It was a lakeside summer spot in New Orleans that inspired the song that would become one of the world's great Jazz masterpieces. 'West End Blues' was a sleepy southern blues tune written by Joe 'King' Oliver, until it came into the hands of trumpeter Louis Armstrong . . . in the late 1920s . . . and changed musical history."

Other local musicians who changed music history and memorialized Lake Pontchartrain include: Leon Roppolo, who began performing in Bucktown at age 11 and later formed the New Orleans Rhythm Kings, who recorded "Milenburg Joys" in 1923; the great Ferdinand "Jelly Roll" Morton, who wrote "Pontchartrain" (recorded in 1930) and recorded "Bucktown Blues" in 1924; and the New Orleans Owls, who recorded "Sailing on Lake Pontchartrain" and "West End Romp" in mid-1920s

Many first heard early New Orleans jazz performed at Milneburg, where Buddy Bolden, the "Father of Jazz," as well as Sidney Bechet, Johnny Stein, Albert and George Brunies, Tony Parenti, Nick La Rocca, and Danny Barker played. Venues in Milneburg included Morgan's Saloon, the Joy Club, Romer's Café, the Inn, Quarelles, Nick's Restaurant, the Lighthouse, fishing camps, dance halls, bandstands, restaurants, roadhouses, picnics, and saloons. Spanish Fort's most notable venues were Tranchina's Hotel Restaurant and Tokyo Garden where A. J. Piron's orchestra played from around 1918 until 1923.

Tom Brown, who claimed to be the first person to use the word "jass," played on the lakefront as well as on excursion steamers to the north shore. The Moonlight Serenaders, led by Alcide "Yellow" Nuñez, played in Milneburg and Little Woods. Trumpeter Gustave Joseph "Sharkey" Bonano was born in Milneburg in 1898. The Halfway House Orchestra took its name from the dance hall so named because it was located halfway between the city and the lake along the New Basin Canal, near the cemeteries.

In Little Woods at Mama Lou's Herb Morand, Richard "Rabbit" Brown and Louis "Kid Shots" Madison performed. During the 1940s, a group of teenagers which included Frank Assunto, his brother Fred, and Pete Fountain played there for free meals—they would later be known as the Dukes of Dixieland. Mama Lou's remained in operation until the 1960s but was badly damaged during Hurricane Betsy in 1965.

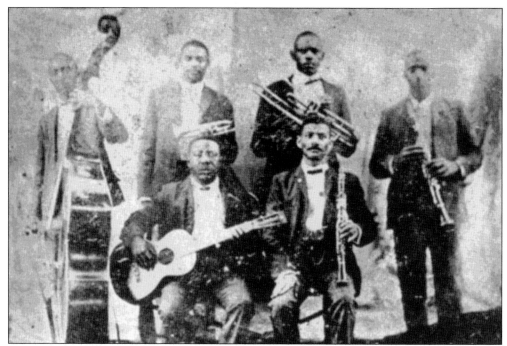

Around the turn of the century, the most renowned jazz player in New Orleans was coronetist Buddy Bolden, who played for dances, parties, and picnics on the lakefront as well as in the city. Standing from left to right are Jimmy Johnson, Buddy Bolden, Willie Cornish, and William Warner. Sitting from left to right are Jefferson Mumford and Frank Lewis. (Courtesy Red Hot Jazz Archive.)

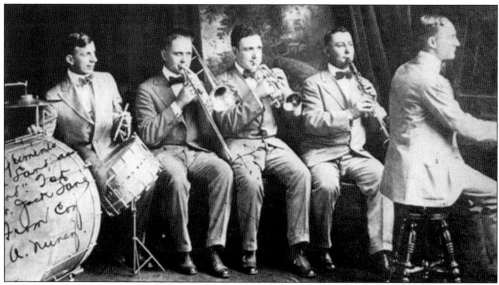

In 1917, the Original Dixieland Jass Band recorded the first jazz record, *Livery Stable Blues*. They claimed to be "The Creators of Jazz" and played often on the lakefront. The band is pictured here in a 1917 photograph, from left to right, as follows: Tony Sbarbaro, Nick La Rocca, Yellow Nuñez, Eddie Edwards, and Henry Ragas. (Courtesy Library of Congress.)

Ferdinand "Jelly Roll" Morton was among the first great jazz composers and pianists. A prolific writer, he memorialized the lakefront with his tunes "Pontchartrain" and "Bucktown Blues." Morton is often credited with writing "Milenburg Joys," but he claimed only to have added the introduction to the Paul Mares and Leon Ropollo composition "Golden Leaf Strut." Morton once said that he received a letter from a German citizen who was pleased that jazz musicians from New Orleans were celebrating the joys of the German city Milenburg when, in fact, local musicians were merely using the common New Orleans pronunciation when naming the tune. (Courtesy Louisiana Digital Library.)

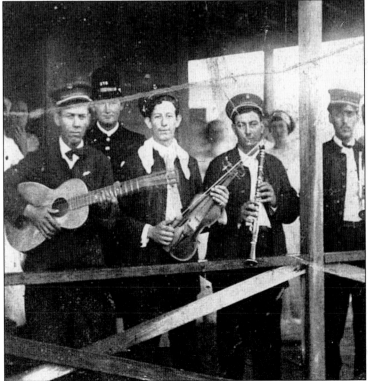

This 1915 photograph includes members of the Frank Christian Ragtime Band on Quarella's Pier in Milneburg. They include (left to right) Harry Nuñez with the guitar, Alcide Yellow Nuñez with the violin, Frank Christian with the clarinet, and Charles Christian with the cornet. Other band members included Manuel Gomez and Kid Totts Blaise. (Courtesy Louisiana Digital Library).

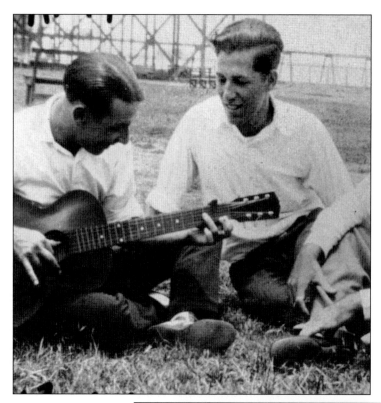

Leon Roppolo is remembered as a pioneer of the jazz solo. At about age 11 he began performing on the New Orleans lakeshore and in Bucktown. His New Orleans Rhythm Kings (also known as the Friars Society Orchestra) recorded "Milenburg Joys" in 1923. Pictured are Leon Roppolo (left) and Louis Prima (right) in 1924 at the lakefront. (Courtesy Library of Congress.)

In 1910, trumpeter "Papa" John Celestin formed the Original Tuxedo Jazz Orchestra, which would become one of the most popular bands in the city. It included, over the years, Peter Bocage, Louis Armstrong, Bebe Ridgley, Lorenzo Tio Jr., and Isidore Barbarin. Many years later, Papa Celestin's band played for a huge crowd at the 1954 rededication of Lincoln Beach amusement park. (Courtesy Louisiana Digital Library.)

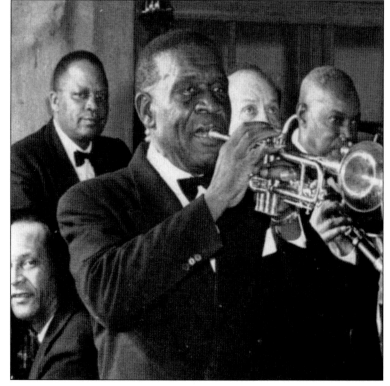

The New Orleans Owls played regularly throughout the city between 1922 and 1929. They recorded "Sailing on Lake Pontchartrain" in 1924 and "West End Romp" in 1926. Band members included Red Bowmen, Sigfre Christensen, Earl Crumb, Moses Farrar, Rene Gelpi, Nappy Lamare, Dan LeBlanc, Frank Netto, Bill Pardon, Lester Smith, Pinky Vidacovich (pictured), and Benjie White. (Courtesy Louisiana Digital Library.)

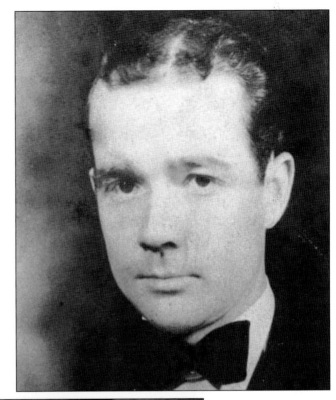

Born in Milneburg in 1898, trumpeter Gustave Joseph "Sharkey" Bonano entered the world as jazz was beginning to brew in his hometown. Sometimes compared to Louis Prima, he was known as a charismatic personality and a fine musician. Never losing touch with his New Orleans roots, Sharkey is pictured here casually dressed, presumably either recording or doing a radio show. Sharkey Bonano passed away in 1972. (Courtesy Louisiana Digital Library.)

Louis Armstrong and his Hot Five's 1928 rendition of "West End Blues" is considered one of the finest jazz recordings of all time. The band included New Orleans–born musicians Johnny St. Cyr, Edward "Kid" Ory, and Johnny Dodds, as well as Armstrong's wife, Lil Hardin-Armstrong. In mentioning the recording, Billie Holiday wrote in her autobiography that she "never heard anyone sing before without using words." "West End Blues" was written by Joe "King" Oliver, Armstrong's mentor. Pictured is a young Louis Armstrong in 1930. (Courtesy Louisiana Digital Library.)

The Moonlight Serenaders, led by Alcide "Yellow" Nuñez, played regularly along the lakefront at Milneburg and Little Woods. Nuñez also played with Papa Jack Laine's Reliance Brass Band, Frank Christian's Ragtime Band, and Tom Brown's Band from Dixieland. Nuñez was an original member of Stein's Dixieland Jass Band and the Original Dixieland Jass Band. He is pictured here with his wife, Hilda, and children Alcide, Robert, and Eugene at Little Woods around 1930. (Courtesy http://web.archive.org/web/20011004152109/www.geocities.com/infrogmation/WCBE.html.)

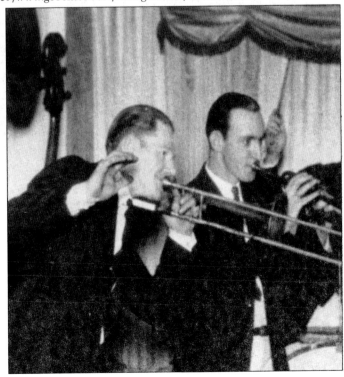

Tom Brown was a veteran of Papa Jack Laine's Reliance Band, the Original Dixieland Jass Band, and Johnny Bayersdorffer and his Jazzola Novelty Orchestra. He claimed to be the first person to use the word "Jass." He played often at lakefront restaurants, pavilions, and cabarets, as well as on the excursion steamers to the north shore. Pictured is Brown on trombone playing in the Johnny Bayersdorfer Orchestra at Tokyo Gardens at Spanish Fort. Bayersdorfer is playing the trumpet. (Courtesy Louisiana Digital Library.)

Frank Assunto led his brother Fred, a very young Pete Fountain, and various other teenagers in his band, which often played at Mama Lou's in Little Woods during the 1940s. They would later call themselves the Basin Street Four, Five, or Six, depending on how many members they could gather. The band often consisted of Frank Assunto on trumpet, Fred Assunto on trombone, Pete Fountain on clarinet, Tommy Balderas on guitar, Willie Perkins on drums, Artie Seelig on piano, and Hank Bartels on bass. In early days, the group billed themselves as the Junior Dixieland Band, but in 1949 they chose the name that stuck—the Dukes of Dixieland. (Courtesy Louisiana Digital Library.)

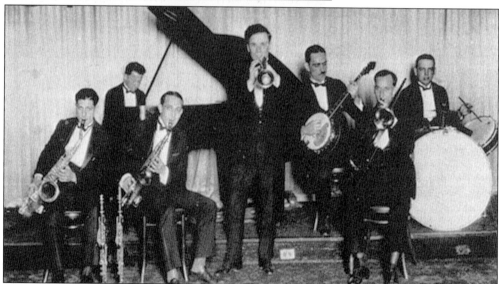

The Halfway House Orchestra took its name from the dance hall so named because it was located halfway between the city and the lake near the New Basin Canal, at what was most recently the Orkin building, near the cemeteries at the end of Canal Street. Band members included leader Albert "Abbie" Brunies (center), Sidney Arodin, Leo Adde, Albert Brunies, Charlie Cordella, Bill Eastwood, Glyn Lea "Red" Long, Mackie Marcour, Chink Martin, Angelo Palmisano, Emmett Rodgers, Leon Roppolo, Johnny Saba, and Bill Whitmore. (Courtesy Red Hot Jazz Archive.)

# *Eight*

# CHANGE

The 1920s and 1930s brought tremendous change to the shores of Lake Pontchartrain, much of it still visible today. The longtime quest to connect the lake with the river was accomplished on a grand scale with the completion of the Industrial Canal. Although the lake's value as a shipping channel and port waned during the end of the 19th century because huge modern ships could not navigate its shallow bottom, the U.S. Army Corps of Engineers designed the canal, which opened in 1921. It terminated at the lake in the eastern section of the city near what would later become the Shushan (now Lakefront) Airport.

Massive land reclamation from West End to just east of the Industrial Canal left the Spanish Fort and Milneburg attractions a half mile or so offshore. Milneburg camps and other over-water structures were demolished. Reclaimed land fronting Milneburg became the Lake Terrace and Lake Oaks subdivisions.

The Spanish Fort amusement area closed in 1926. Before the reclamation, the lakeshore reached approximately to what is now Robert E. Lee Boulevard, which was then named Adams Avenue.

When the Maestri Bridge was completed in 1928, it was considered to be the world's longest continuous concrete highway bridge.

In 1931, the Army Corps of Engineers designed and opened the Bonnet Carre Spillway, allowing waters to flow from the Mississippi River to the lake when high tides from the river threaten to flood New Orleans. The spillway was first opened in 1937.

The Shushan Airport, named for the Orleans Levee Board president Abraham Lazar Shushan, opened in 1934 as one of the premier airports in the United States. Built on reclaimed land, it is located on the lakeshore near Hayne Boulevard at Downman Road.

By 1937, the New Orleans Lakeshore Drive had been coined the "Great White Way." Because of its modern lighting system. While the massive reclamation project was taking place on the New Orleans shore, across the lake in Mandeville, the WPA had plans to beautify the northern shore as well. A seawall was completed there in 1938.

The Industrial Canal (also known as the Inner Harbor Navigation Canal) is yet another man-made project designed to link the Mississippi River to Lake Pontchartrain. It was the first to actually succeed by the use of locks to accommodate the difference in lake and river tide levels. It was completed by the U.S. Army Corps of Engineers in 1921 as a five-and-one-half-mile waterway with a depth of 30 feet. (Courtesy Wikipedia.)

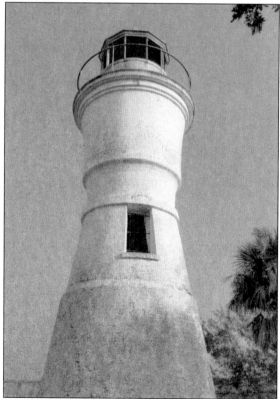

In 1926, the Orleans Levee Board began driving pilings at Milneburg which would support sheet pilings that would then be backfilled to create new land. The project spanned the shore from West End to the Lakefront Airport. After completion, the Milneburg Light (pictured) would be on dry land surrounded by the Pontchartrain Beach amusement park. (Courtesy New Orleans Public Library.)

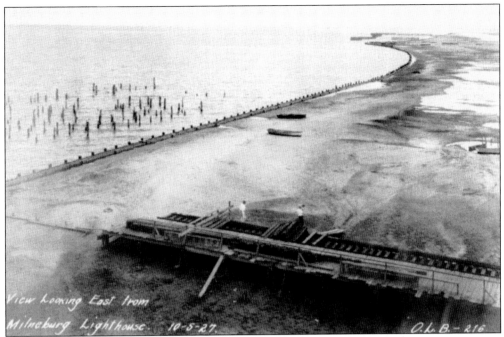

The photographer shot this photograph from inside the Milneburg Lighthouse in 1927. Note the pilings from demolished structures. Most Milneburg camps were destroyed. Some were moved by their owners to New Orleans east along Hayne Boulevard or to Little Woods. (Courtesy New Orleans Public Library.)

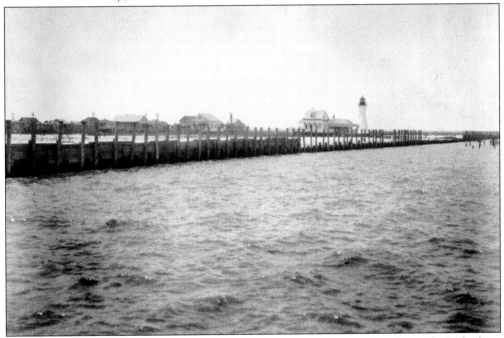

This 1928 photograph illustrates the amount of land that would be reclaimed near the Milneburg Light. The areas on the left of the bulkhead would become Pontchartrain Beach amusement park. Note the camps along the original shore. (Courtesy New Orleans Public Library.)

While work was being done at Milneburg, the area at Bayou St. John and Spanish Fort was destined for the same. In this 1928 view, Spanish Fort amusement park was still on the lakeshore. Note the Ferris wheel on the right. (Courtesy New Orleans Public Library.)

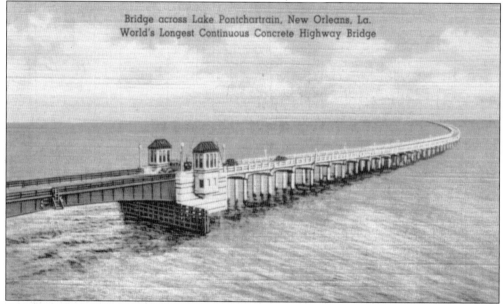

Bridge across Lake Pontchartrain, New Orleans, La.
World's Longest Continuous Concrete Highway Bridge

Another major public works project, the Maestri Bridge (also known as the Five Mile Bridge, the Pointe Aux Herbes Bridge, and the Watson-Williams Bridge), was undertaken on the eastern shore at this time. It was considered to be the world's longest continuous concrete highway bridge. The back of this postcard reads, "Bridge completed in 1928—5 miles long. This Bridge is part of the 'Old Spanish Trail,' from Palm Beach, Florida, to Los Angeles, Cal. Route U.S. No. 90." The claim as world's longest would later be made by the Lake Pontchartrain Causeway when it opened in 1956 and again with the addition of the second, slightly longer span in 1969. (Courtesy New Orleans Public Library.)

In West End, a reclamation project was also taking place. The caption on this photograph reads "ZONE 1. 25 feet east of the West End light house shell road and 200 ft. south of the sea-wall. Picture taken Nov. 27, 1931. Dredge 'Houston' stopped pumping in this zone on November 7, 1931. Arrow [barely visible, center] points to Arthur Barry standing in fill 2.4 ft." (Courtesy New Orleans Public Library.)

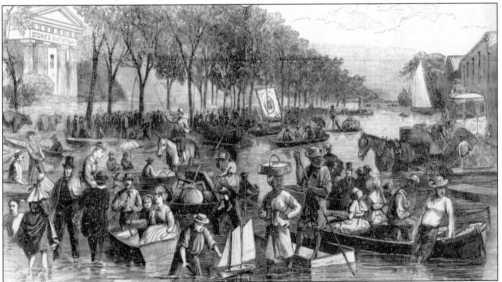

This 1871 engraving by Alfred R. Waud and Samuel S. Kilburn illustrates a view of a slightly flooded Canal Street near Claiborne Avenue. Much of the city took on water as the result of a crevasse at Bonnet Carre, which overflowed the lake with Mississippi River water. In 1931, the U.S. Army Corps of Engineers designed and opened the Bonnet Carre Spillway, allowing a controlled flow of water from the river to the lake. The spillway is located on the southern shore, west of New Orleans. (Courtesy Wikipedia.)

This 1936 photograph includes a scale model of a section of the land reclamation project for the New Orleans lakeshore. This housing development would be built on what was formerly the lake. (Courtesy New Orleans Public Library.)

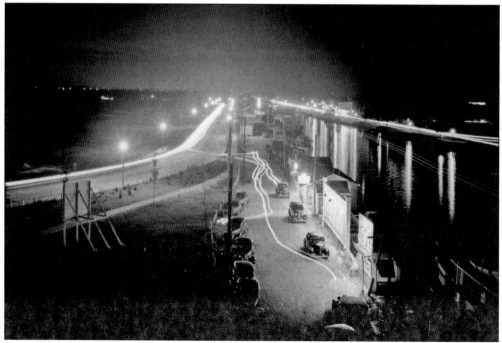

By 1937, the New Orleans lakeshore had been coined the "Great White Way" and was said to have one of the finest lighting systems in the South. Here is a view of West End Boulevard looking from the lake. The New Basin Canal is on the right. (Courtesy New Orleans Public Library.)

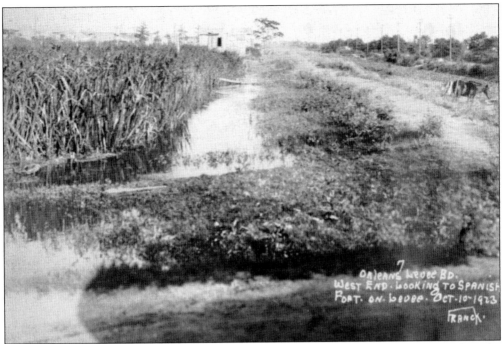

This photograph, taken by the New Orleans Levee Board on October, 10, 1923, before the reclamation, is captioned "West End. Looking to Spanish Fort. On. Levee." Camps are barely visible in the distance. (Courtesy New Orleans Public Library.)

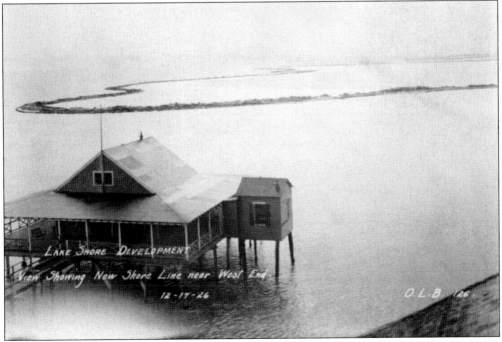

In this 1926 view of a doomed camp, the caption reads "LAKE SHORE DEVELOPMENT . . . View Showing New Shore Line near West End . . . 12-17-26 . . . O.L.B. [Orleans Levee Board]." (Courtesy New Orleans Public Library.)

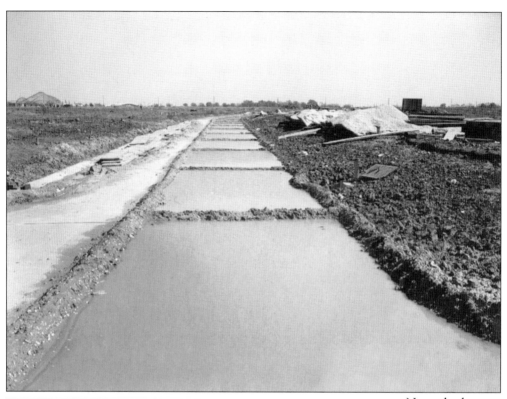

New suburban streets are shown curing in this 1938 photograph. Note the Pontchartrain Beach amusement park's Zephyr in the left background. (Courtesy New Orleans Public Library.)

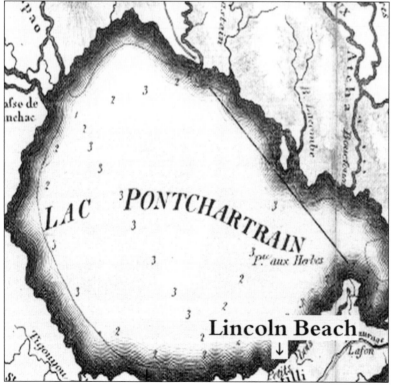

This map indicates the approximate location of Lincoln Beach, which was built during the late 1930s as a recreation and amusement area in New Orleans East.

Lincoln Beach amusement park was located off Hayne Boulevard between Shushan Airport (now Lakefront Airport) and Paris Road. The 1939 photograph (top) shows the proposed location with boulders in place that would contain the man-made beach. Note the Hayne Boulevard camps in the background. The aerial photograph (bottom) includes a view of the completed beach project as well as the early stages of construction of the WPA-funded amusement park. (Courtesy New Orleans Public Library.)

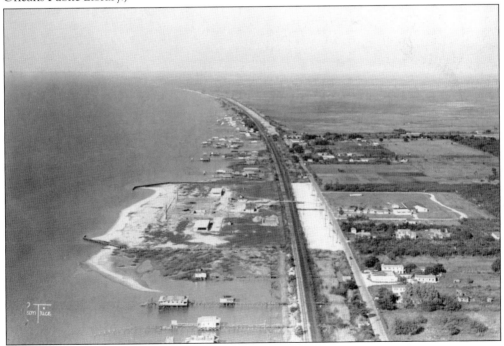

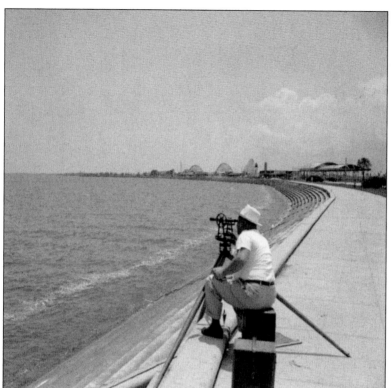

A worker surveys the proposed Pontchartrain Beach location in 1939. The New Orleans Levee Board hired a dredger under a private contract, but WPA workers would spread the two-foot-deep white-sand topping. The amusement park can be seen in the distance. (Courtesy New Orleans Public Library.)

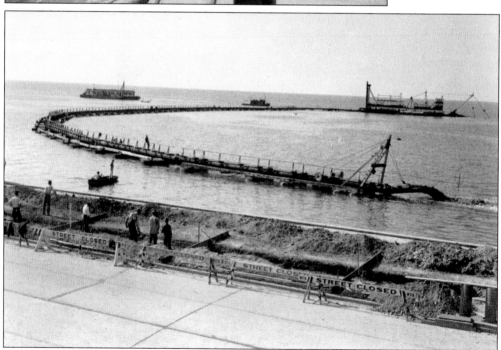

Later in 1939, work began on the sand beach. WPA plans also included a swimming pool, bathhouse, parking areas, and roads to and from the amusement park on Elysian Fields Avenue. (Courtesy New Orleans Public Library.)

Shushan Airport opened in 1934 on reclaimed land just east of the Industrial Canal. It was the first combined land-and-seaplane air terminal in the world. This map shows the approximate location of the airport.

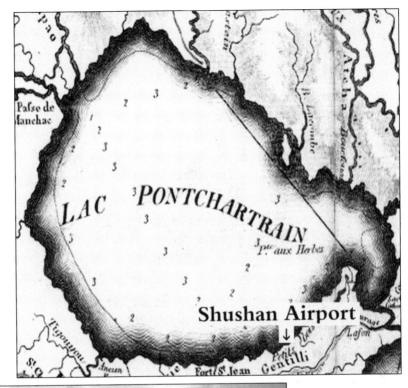

This photograph shows the Shushan Airport administration building shortly after its opening. The facade of this art deco structure would later be covered with panels. (Courtesy New Orleans Public Library.)

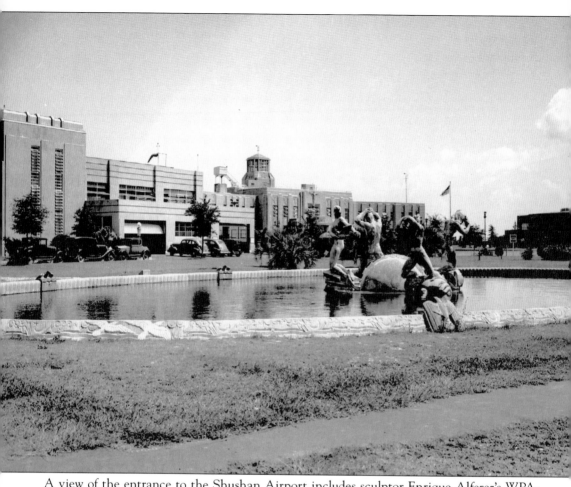

A view of the entrance to the Shushan Airport includes sculptor Enrique Alferez's WPA-commissioned *Fountain of the Winds*. (Courtesy New Orleans Public Library.)

# *Nine*

# WAR AND
# PEACEFUL PURSUITS

World War II put plans for many residential and recreational developments along the New Orleans lakeshore on hold. Much of the reclaimed shore became the home of (from west to east) the U.S. Coast Guard Light House Station at West End, the adjacent U.S. Army Base Hospital and LaGarde General Hospital, the U.S. Naval Hospital, the U.S. Coast Guard Station at Bayou St. John, the U.S. Maritime Commission (on Bayou St. John near the lake), the Naval Reserve Aviation Base Aircraft Carrier Training Center (between the London Avenue Canal and Elysian Fields Avenue—now the University of New Orleans), the Navy Assembly Plant and Consolidated Vultee Aircraft Company (east of Pontchartrain Beach), the German P.O.W. Camp, the U.S. Army Bombing Squadron (just west of the Industrial Canal), and the National Guard Hanger and Seaplane Ramp (between the Industrial Canal and the Shushan Airport).

Higgins Industries designed and built World War II vessels (including the famed LCVP landing boats) in plants located on City Park Avenue abutting Bayou St. John and along the Industrial Canal. The bayou, canal, and lake were used during the war to test the boats. Evidence of wartime testing still exists in the high signal signs along Lakeshore drive; mile markers used to gauge the speed of Higgins boats.

Hurricane Katrina was not the first occurrence of a breach in protection of the Seventeenth Street Canal walls. During a 1947 storm, several breaks accounted for flooding in Jefferson and Orleans Parishes (primarily along the lakefront and in Gentilly).

Lakefront attractions had enticed locals and visitors for more than a century before Lincoln Beach was opened exclusively for "negroes." Although Milneburg had allowed for mixing of the races, it was somewhat unique in that respect. During the 1930s, the WPA planned a 10-acre park off Hayne Boulevard in New Orleans East. Lincoln Beach opened in the early 1940s, but it wasn't until 1953 that the New Orleans Levee Board began a half-million-dollar renovation that matched some of the amenities offered at Pontchartrain Beach. The renovation included freshwater swimming pools, a new bathhouse, picnic shelters, and an expanded and rebuilt midway. Noted musicians performed at Lincoln Beach, including "Papa" Celestine, Fats Domino, and Sam Cook. The park was closed in 1964 by a federal order forbidding the operation of segregated facilities. Pontchartrain Beach amusement park moved from its original location near Spanish Fort to Elysian Fields Avenue on the lakefront in 1940. It closed in 1983.

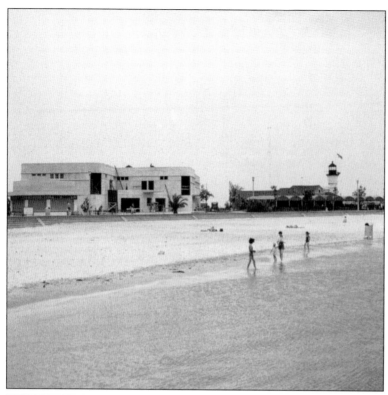

People are enjoying the new beach at the end of Elysian Fields Avenue in 1940. Note the sleek bathhouse (still under construction), and the Milneburg Lighthouse on dry land (above) and the ultra-modern lifeguard stand (below). (Courtesy New Orleans Public Library and Louisiana Digital Library.)

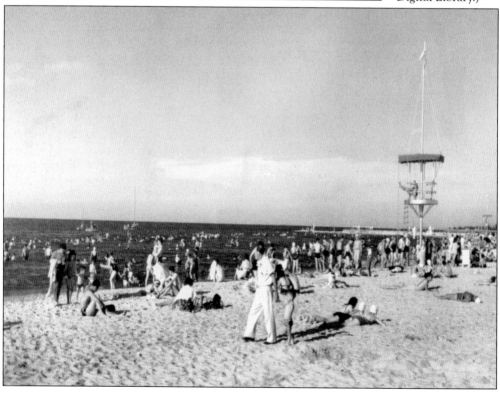

In this 1941 view of West End (looking toward the city) the U.S. Army base hospital and LaGarde General Hospital are in the left background. Note the New Basin canal on the right. The building in the foreground would later become Bart's, owned by Sherwood "Big Wheel" Bart. Compare this view to the 1937 nighttime photograph on page 100. (Courtesy Henry Harmison and the New Orleans Public Library.)

This 1941 photograph shows the Industrial Canal Bridge (formally named the Sen. Ted Hickey Bridge but also known as the Seabrook Bridge). Plans included extending Lakeshore Boulevard to the Industrial Canal, where this new bridge would link to the Shushan Airport and Hayne Boulevard. (Courtesy New Orleans Public Library.)

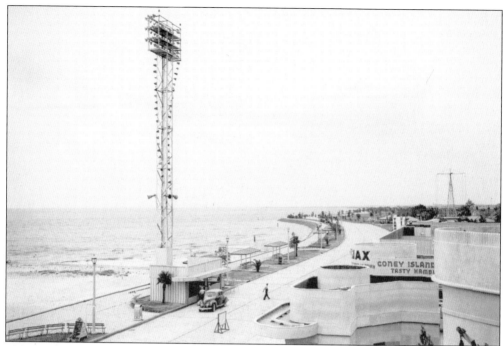

This photograph was taken in 1941 from inside the Milneburg Lighthouse and depicts the midway at Pontchartrain Beach amusement park. Compare this photograph with the 1927 view on page 97. (Courtesy New Orleans Public Library.)

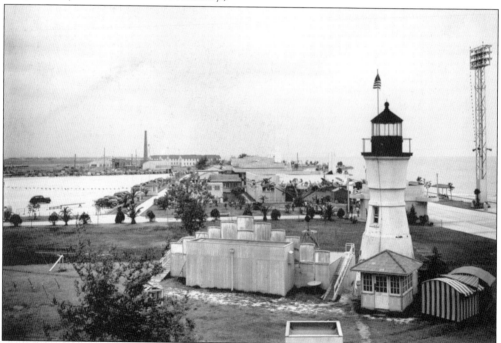

Pontchartrain Beach amusement park is pictured in this 1941 view. The smokestack and surrounding property in the rear are part of the U.S. Naval Reserve Air Training Base. (Courtesy New Orleans Public Library.)

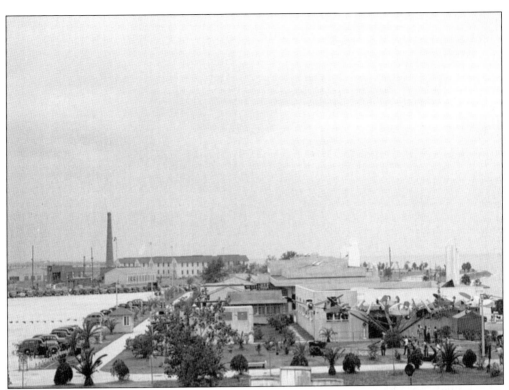

Pontchartrain Beach amusement park in 1941 is viewed from near the Milneburg Lighthouse. Some of the amusement rides had been moved from the original Pontchartrain Beach near Spanish Fort. (Courtesy New Orleans Public Library.)

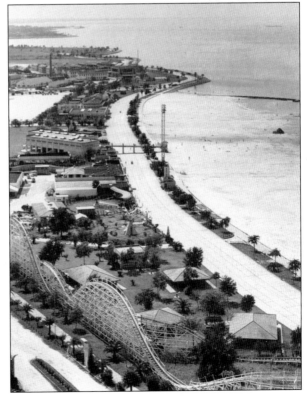

By 1941, the old Milneburg Light was no longer sitting on pilings in the lake, and its keeper's home (a camp, also on pilings) was gone. It had been deactivated and was now little more than an historic prop in Kiddieland. In this photograph, it is dwarfed by surrounding structures. (Courtesy New Orleans Public Library.)

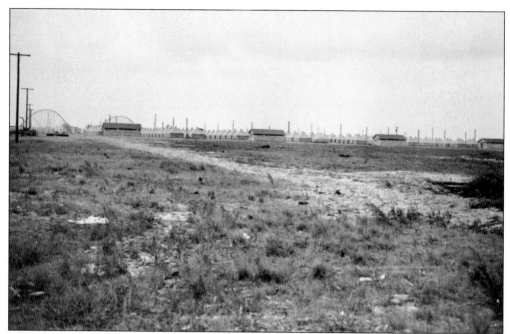

The Zephyr at Pontchartrain Beach amusement park can be seen on the left in this 1941 photograph of the U.S. Army recreation center. This is the approximate location of the 1923 view of camps in Milneburg on page 34. (Courtesy New Orleans Public Library.)

This 1948 photograph shows the U.S. Naval Air Station just west of Pontchartrain Beach. In 1958, it would become the campus of Louisiana State University in New Orleans (LSUNO), which would be renamed University of New Orleans (UNO) in 1974. The Pontchartrain Beach amusement park property is now UNO's Research and Technology Park. (Courtesy New Orleans Public Library.)

The U.S. Coast Guard Station is viewed from Lakeshore Drive at Bayou St. John in this c. 1948 photograph. It no longer exists. In the top right can be seen some of the newly paved streets that would become Lake Vista subdivision. Land across the bayou would later be used for the Lake Terrace development. (Courtesy New Orleans Public Library.)

This 1941 photograph captures the dedication of the partially completed U.S. Naval Reserve Air Training Base. The base was funded by the WP A and the navy. In 1947, the base was renamed Camp Leroy Johnson in honor of the World War II Congressional Medal of Honor recipient who gave his life to save his fellow soldiers. (Courtesy New Orleans Public Library.)

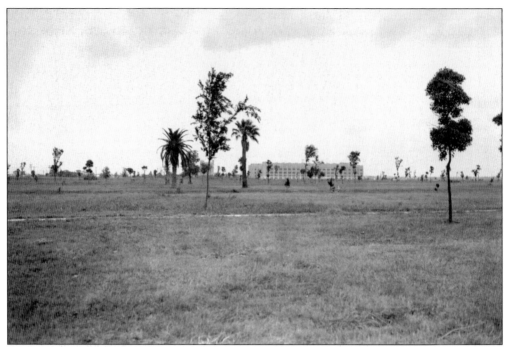

The Southern Regional Research Laboratory is viewed in 1941. The cornerstone had been set on December 29, 1939, in the 40-acre building site. This area had formerly abutted the grounds of Spanish Fort amusement park and resort. (Courtesy New Orleans Public Library.)

This undated photograph provides a seldom-seen view of the briefing room in the New Orleans civil-defense bunker. The shelter was built on the neutral ground between West End Boulevard and Pontchartrain Boulevard near the lake atop what was the New Basin Canal. Although abandoned and weed infested, it still remains. (Courtesy New Orleans Public Library.)

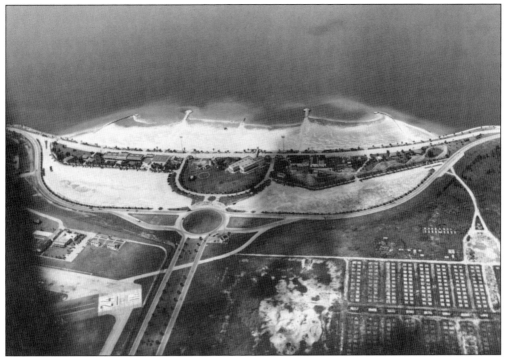

Above is a late-1940s Army Corps of Engineers photograph of Pontchartrain Beach. It is now the location of the University of New Orleans Research and Technology Park. Camp Leroy Johnson can be seen in the lower left corner and in a closer view below. (Courtesy New Orleans Public Library.)

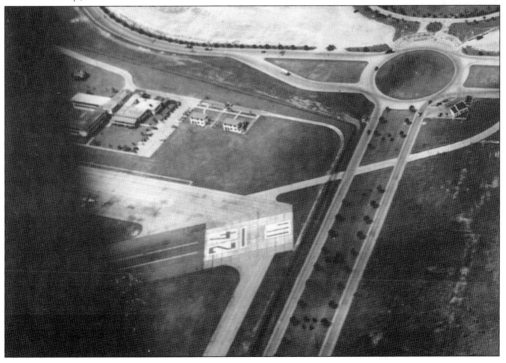

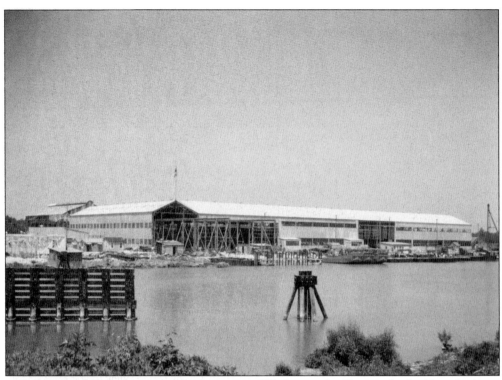

Workers at the Higgins shipbuilding facilities on City Park Avenue at Bayou St. John and along the Industrial Canal built World War II vessels. President Eisenhower called Andrew Higgins, "The man who built the boats that won the war." The caption on the 1940s photograph reads "This large, sprawling war plant stretching along the Industrial Canal at New Orleans is turning out two types of vessels. Shallow-draft, 180 foot, Diesel powered cargo vessels are being built on a moving production line. . . . They are being built for the Army. Fifty foot steel welded tank lighters are constructed on another line in this plant." (Courtesy New Orleans Public Library.)

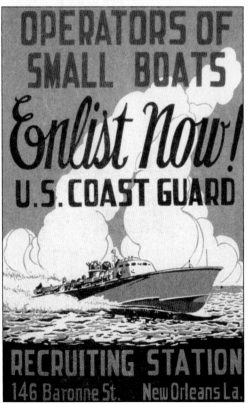

During World War II, the military called upon small boat operators to "Enlist Now!" at the recruiting station on Baronne Street. (Courtesy Library of Congress.)

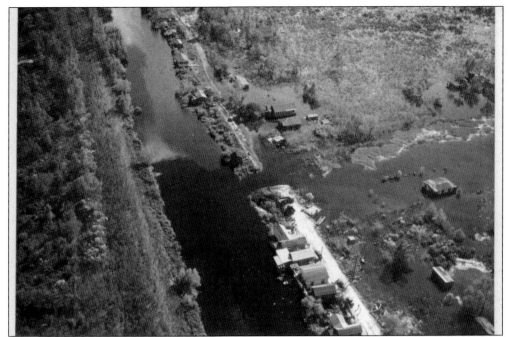

In September 1947, the Seventeenth Street Canal overflowed at several points on the Jefferson Parish side. Note the fishing camps along the canal. The hurricane which caused this break also resulted in flooding in some areas of Orleans Parish. Compare this view to the photograph of post–Hurricane Katrina flooding in September 2005 on page 50.(Courtesy New Orleans Public Library.)

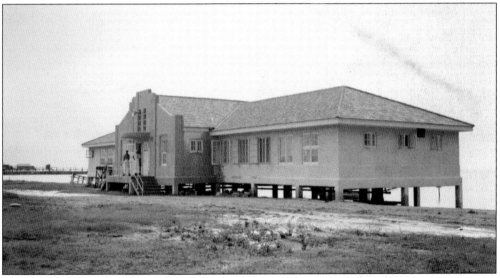

By 1941, the WPA completed construction of this bathhouse at Lincoln Beach and opened it to swimmers. The area was planned as a "negro" beach and recreation park. The 10-acre plot with paved walks and a shell parking area was a far cry from the elaborate scheme the agency had planned and completed for the all-white Pontchartrain Beach. After a half-million-dollar renovation in 1953, this bathhouse was converted into a restaurant. Note the Hayne Boulevard camps to the left. (Courtesy New Orleans Public Library.)

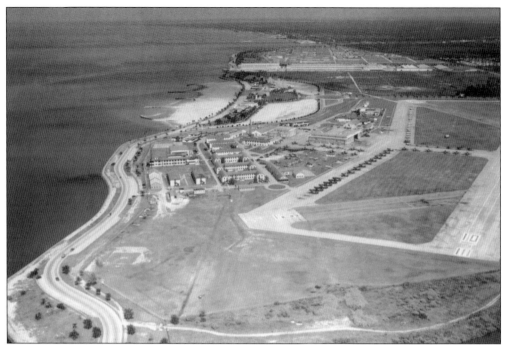

This 1948 aerial view shows the U.S. Naval Air Station/Camp Leroy Johnson in 1948. Pontchartrain Beach is in the middle ground. Beyond it is the Consolidated Vultee Aircraft Company at Franklin Avenue. (Courtesy New Orleans Public Library.)

Looking toward the lake, the London Avenue Canal is seen with the Naval Air Station on the right. Property to the left of the canal is now the Lake Terrace subdivision. (Courtesy New Orleans Public Library.)

# *Ten*

# LIFE ON THE LAKE

From the 1800s until 2005, people lived on the lake in wooden camps built on pilings over the water. Some camps were small and spare; others were large and finely appointed. The old Southern Yacht Club could be considered the grandest camp ever built on Lake Pontchartrain, while a small fisherman's shack in Bucktown might have been the simplest, but all were treasured, because to live on the lake was a unique and rare experience.

The camps were so beloved that their owners bestowed names upon them, some grand, some fanciful, most unique. They included Two R's, PEE and RRR Cottage, Jolly Roger, My Sons, Lulaine, the Barge, Playtime, DatsaMaCamp, E's and B's, Dukes Camp, Chick-A-Dees, Red Mike, Zanca's Old Glory, Camp-a-Nella, Six Little Fishes, Louis-A, Petticoat Junction, Anadelle, Sportsman Paradise, All in the Family, Suits Us, Two Crabs, Gloria, Smiley and Fritz, Gris Gris, LaLa's Full House, Emdee, Doll House, Our Camp, M and R Place, B and L, Three Sons and A Daughter, Blues, Lil Billy's Men Cottage, Sunny Susan, Pops, Bohemia, Tony and Kathy, Linus Pleasure Cottage, My Happiness, Walter's Camp, Miss Bee, Three Little Sisters, Champs Camp, Setting Sun, Sands of Pleasure, Our Palace, Far Out, Two Bees, High Hopes, Royal Flush, La Marque, Alma Cottage, Shultz's Happy Hour, Dude's Rest, MJM, The Pavilion, Bill's Place, Three Daughters, Ra-Ron, Frick and Frack, Mama Lou's, and White's Castle.

Over the years, progress, nature, and changing lifestyles took their toll on the camps. The Milneburg camps were demolished during the 1920s and 1930s to make way for lakeshore land reclamation. The famous hurricanes (Audrey in 1957, Betsy in 1965, and Camille in 1969), as well as assorted minor storms, damaged or destroyed many Hayne Boulevard and Little Woods camps. In 1998, Hurricane Georges badly damaged Fitzgerald's and Bruning's (the last remaining over-water restaurants) at West End, wiped out an estimated 65 Hayne Boulevard camps, and destroyed 5 camps in Little Woods.

In the early summer of 2005, Sid-Mar's Restaurant served seafood to visitors in Bucktown. Approximately 25 camps stood in Little Woods, with 5 remaining along Hayne Boulevard. In late August of that same year, all were gone but one solitary camp in Little Woods.

In this chapter, we take a look at one family's camp as it relates to the others that came before it in the long history of New Orleanians living on the lake. It is fitting, that the final image depicts the family leaving the camp for the last time on August 27, 2005. Two days later, it was lost, as were so many other well-loved structures, in the aftermath of Hurricane Katrina.

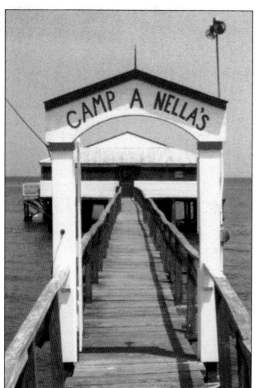

Built in 1925, Camp-A-Nella was originally named St. John's Cottage, then Lakecrest Cottage. It survived Hurricane Georges in 1998, leaving it one of 6 camps remaining of about 70 along Hayne Boulevard between the Lakefront Airport and Paris Road. Although the storm caused much damage, most of the original camp remained. Of architectural interest was its board-and-batten construction (also known as "barge board" construction). Both interior and exterior walls were composed of 1-inch-by-10-inch cypress boards, which extended through the floors to the joists below. The survival of this camp through many storms was most likely due not only to its height above the water, but also to its old-time style of construction. While repairing the camp after Hurricane Georges, much care was taken to restore it as much as possible to its original style—hardwood plank flooring and many of the barge boards were salvaged from the rock levee where they had been carried during the storm. Camp-a-Nella was owned by Vincent and Meredith Campanella.

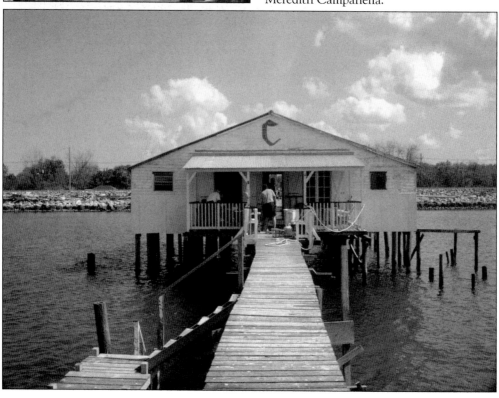

Typical of most Lake Pontchartrain camps, Camp-a-Nella included several bedrooms, a large interior room, porches, and piers. The camp once had a large wrap-around screened porch that flanked both sides and the front. Porches were used for gathering, eating, card playing, and sleeping. The top photograph shows the side porch around 1980. In the bottom photograph, a family reunion is taking place on the back pier around 1986. Zanca's Old Glory can be seen at the top center.

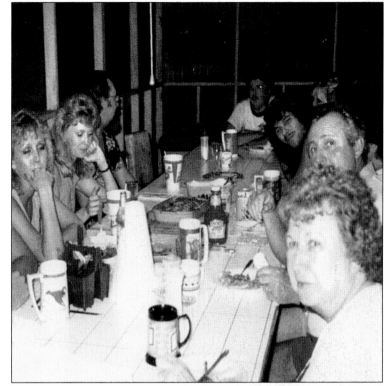

In the top photograph, Eddie Krass shows off his catch, but looking over his shoulder, one can view some of the camps that once lined Hayne Boulevard. They include Six Little Fishes, Louis-A, Big Lou's, and the Port Hole (formerly Amelia A). In the bottom photograph, (from left to right) Helen Generos, a friend, Joan Bienvenu, and Harry Breaux enjoy boiled crawfish on the back porch in 2005. In the distance, only Dan and Annette Rein's Six Little Fishes can be seen. The others were destroyed in Hurricane Georges. (Courtesy Julie Krass Kroper.)

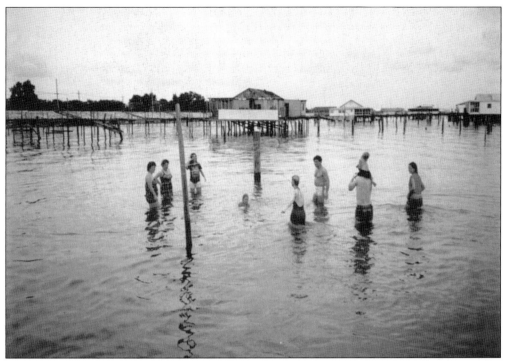

A volleyball game takes place in the lake along side Camp-a-Nella during the mid-1980s. In this photograph can be viewed the remains of Sonny's (which had burned), Red Jack's, Chick-a-Dee, the Duke, All in the Family, and E's and B's, among others. In the bottom photograph, taken from approximately the same vantage point in 2004, only All in the Family and the Camp (in the distance) remain. (Courtesy Julie Krass Kroper and Beth Fury.)

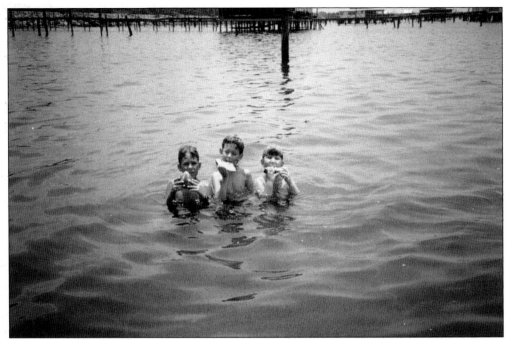

Camp owners had the luxury of opting for eating in or on the lake. During the late 1980s, (from left to right) Andrew Azzarello, Robert Campanella, and John Campanella (top) enjoyed cold watermelon. Grown-ups (bottom) had boiled crawfish on the back porch in 2004. Camp owners of note included Gov. Huey Long, Mayor Robert Maestri, Mayor Chep Morrison, and "Diamond Jim" Moran. Pres. Franklin Roosevelt once stepped off the train in Little Woods to enjoy a brief visit. Elvis Presley's King Creole was filmed at a Hayne Boulevard camp. (Courtesy Julie Krass Kroper and Beth Fury.)

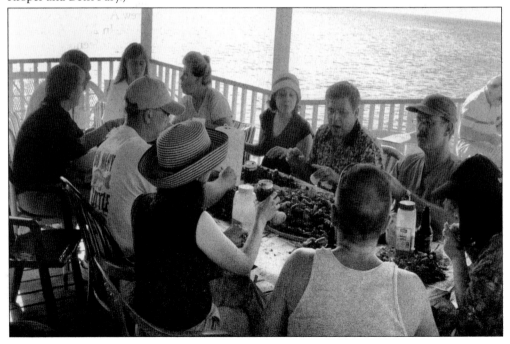

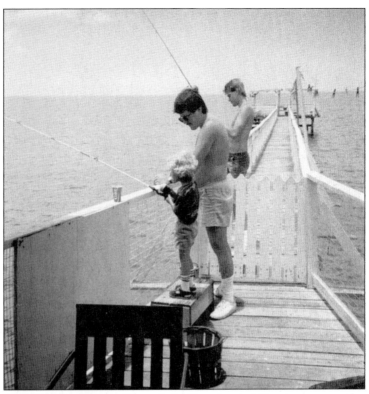

Lake Pontchartrain camps were wonderful places to relax but also required much upkeep and repair. Vincent Campanella Jr. teaches his nephew Andrew Azzarello how to fish (top) c. 1986. In 2004, Andrew's grandfather Vincent (center) is working along with Darryl Fury (front) and Tom Munger (rear) to repair the back walk after it was damaged in a storm (left). (Courtesy Beth Fury.)

One of the glories of life on the lake was the intermingling of generations and the passing down of family legends and lore. Gloria Knower Pohlmann and her brother Edward (Jake) Knower (pictured above) were such storytellers. Dawn Bowers Benfield tells about the camp (right) that was next door to Camp-a-Nella: "My grandparents owned a camp on Lake Pontchartrain which was called THE OLD GLORY. They sold this camp to the Zanca's sometime in the 40's. It originally was built as a 'Play House' . . . I remember it was a restaurant when I was 4 years old (1931) . . . Mr. Zanca was one of her customers . . . I remember there was Mama Lou's, The Happy Landing, The Old Glory and the Ruby owned by the Bourda family, all in the restaurant business at that time." (Courtesy Dawn Bowers Benfield.)

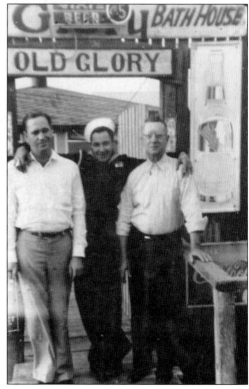